Taking Liberties

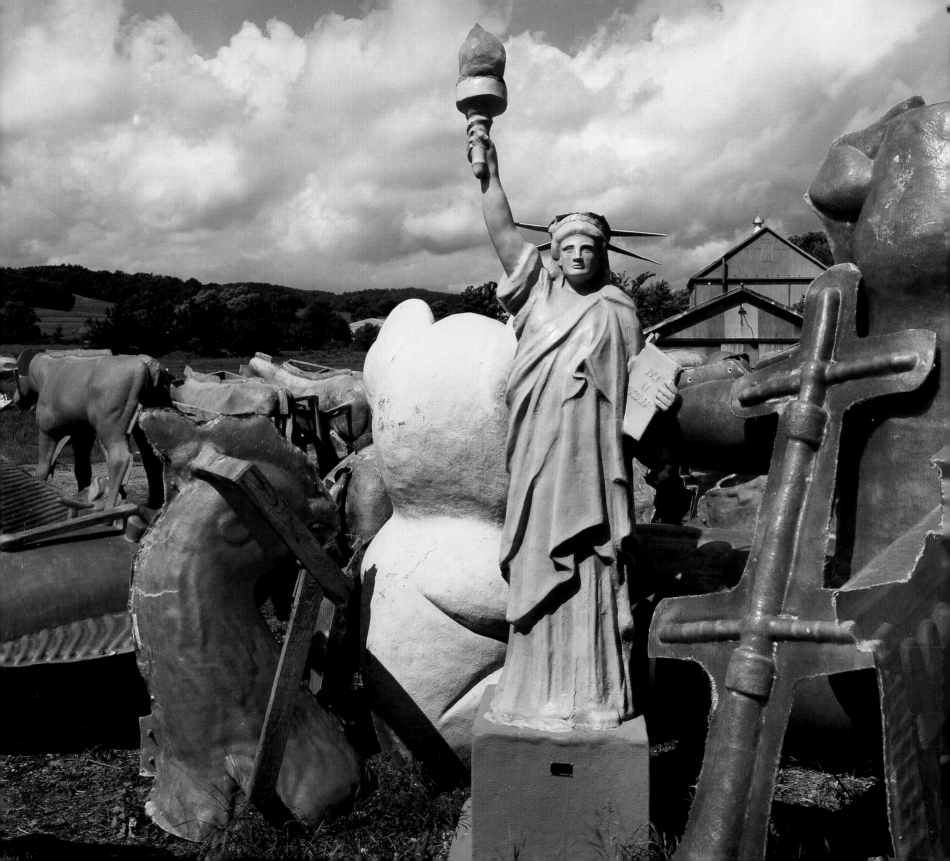

Taking Liberties

Photographs by **David Graham**

Introduction by Robert Venturi

A Pond Press Book

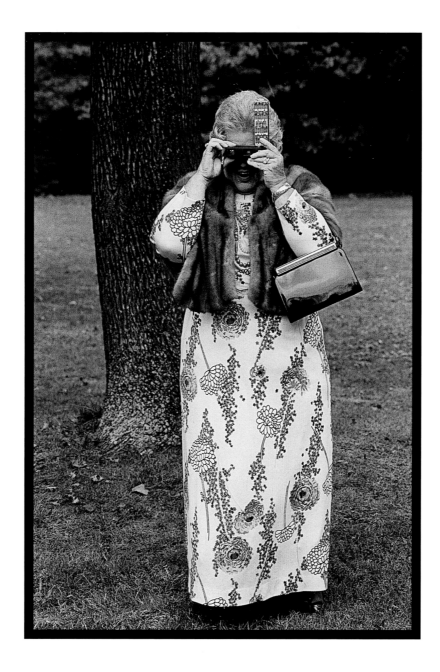

To my Mom, who spoiled me rotten and let me do whatever I wanted,
which is how you come to be holding this book in your hands.

PHOTOGRAPH BY MARK DANIELS · 9/25/76

Pond Press
1140 Washington Street
Boston, MA 02118
www.pondpress.com

Distributed by
Consortium Book Sales
& Distribution
1045 Westgate Drive
St. Paul, MN 55114
1-800-283-3572

Printed and bound in the United Kingdom by Butler and Tanner

Designed by Phillip Unetic, Willow Grove, Pennsylvania

Library of Congress control #2001090587

ISBN: 0-9666776-6-8

First Edition

Acknowledgements

In the earlier books, I have been very general in my thanks. In "Taking Liberties", I would like to be very specific in who I thank. Jacqueline van Rhyn, curator at The Print Center in Philadelphia was instrumental in straightening out the sequence of photographs. Kate Ware, of the Philadelphia Museum of Art, was helpful in ironing out a couple of the remaining rough spots.

My favorite architect, Robert Venturi, was kind and generous to bless this book with an introduction. I cannot thank him enough. I feel very proud to have his name share a cover with mine.

Speaking of the cover, and the rest of the book, I would like to rave about my fantastic designer and friend, Phil Unetic. I felt totally at ease with the entire project because I knew Phil would make whatever I did look great. I hope we get to work together again and again.

As a learned advisor, Henry Horenstein was invaluable in keeping me on the correct path to completion. I have appreciated his advice on many matters for many years.

I would also like to thank the friends and fellow photographers who helped me to whittle down the huge stacks of photographs, old and new, that comprised this body of work. Randy Bye, Sandy Sorlien, John Woodin, Amy Kosh, Judy Gelles, Barbara Proud, Colleen McCarthy, and Brian Pineda were my harsh editors. Justin Pekera was also a great help by providing last minute scans in a hurry.

Lastly, I must thank my talented and hard working wife, Jeannine Vannais, for helping me through all the surprises we have faced from the beginning of this work, which began in 1978, to the finish of the third book in 2001. I couldn't have done it without her.

*Pond Press and David Graham gratefully acknowledge
the generous support for this publication provided by:*

Caroline Bennett
Dana and Neil Cohen
Paula and Mark Craig
Penny Ettinger and Kris Bauman
Linda Espanshade Heinemann and Bill Heinemann
Lynne Honickman
Betsey and Bob King
Diane and Paul LaBas
Marty Moss-Coane and Jim Coane
Judith and Frank Norris
Amy Orr and John Woodin
Ann and Norval Reece
Chris Stanton
Kippy Stroud
Kingdon W. Swayne
Sally and Peter Thompson
Brenda and Evan Turner
Diane B. Vannais
Charles Waldren
Deidre Young and Jim Fuller

Additional support was generously provided by:

The James A. Michener Art Museum
The Snyderman Gallery
The University of the Arts

Taking Liberties

James A. Michener Art Museum

Bucks County, Pennsylvania

October 20, 2001–January 27, 2002

138 S. Pine Street

Doylestown, PA 18901

215-340-9800

http://www.michenerartmuseum.org/

*This exhibition is generously supported by
William Draper Cabinetmaker, with additional
support by 3-D Printing and Copy Center, Inc.
and Newtown Office Supply, Inc.*

Introduction

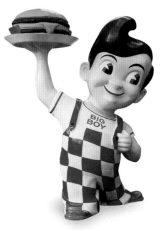

Do the photographs of David Graham engage the real as poetic, the ordinary as extraordinary, the everyday as eternal?

Graham's aesthetic interpretation and celebration of reality within American culture represents not an original approach in art. There is the precedent, of course, of Dutch genre painting of the 17th century depicting bourgeois delight, of 19th century Realist schools of painting celebrating peasants in fields and bohemians in cafés rather than gods in Arcadia or nobles in palaces. And there are Beethoven's third movements based on peasant tunes and Michelangelo's St. Peter's dome based on convention rather than originality—Brunileschi did it first in Florence. Viva reality and convention in terms of content and technique!

And then there is magnificent precedent within Graham's own medium; that of the work of Walker Evans. But between the work of the two photographers there is a significant difference and in this context, vive la différence!—where the reality within the content of Evans' work explicitly engages social dimensions within the American scene and that of Graham's work explicitly engages issues of taste within the American scene. And this can make Graham more controversial or harder to take than Evans because of condescension concerning levels of taste in general and of intolerance concerning commercial iconography as a significant element of American culture in particular. The art of our time, that of Graham, can acknowledge and accommodate multiculturalism and varieties of taste cultures as defined by the urban sociologist, Herbert Gans. Can't we celebrate vitality within vulgarity? Will not someday commercial billboards hang next to patchwork quilts in American craft museums?

Another difference emerges between the art of Evans with its explicitly social content and that of Graham with its explicitly cultural content—another difference which works to illuminate the work of Graham—and that is the subject/content of the art as well as the expression within the art of Graham engages communication. Ornament and advertising depicted within the American environment engage ways of explicit communication so that you have communication about communication and this makes for richness of method as well as of content for our Information Age.

And then there is the element of juxtaposition within Graham's art interpreting and celebrating the everyday American experience involving ranges of mess—iconographic and natural, including statues of Lenin, balloons as pumpkins, real motels and pretty scenery—that make for richness via tension in the art. Viva messiness over unity!

In the end, must not David Graham's art be admired for its profound quality and loved for its consummate wit plus joy?

Robert Venturi, 5/2/01

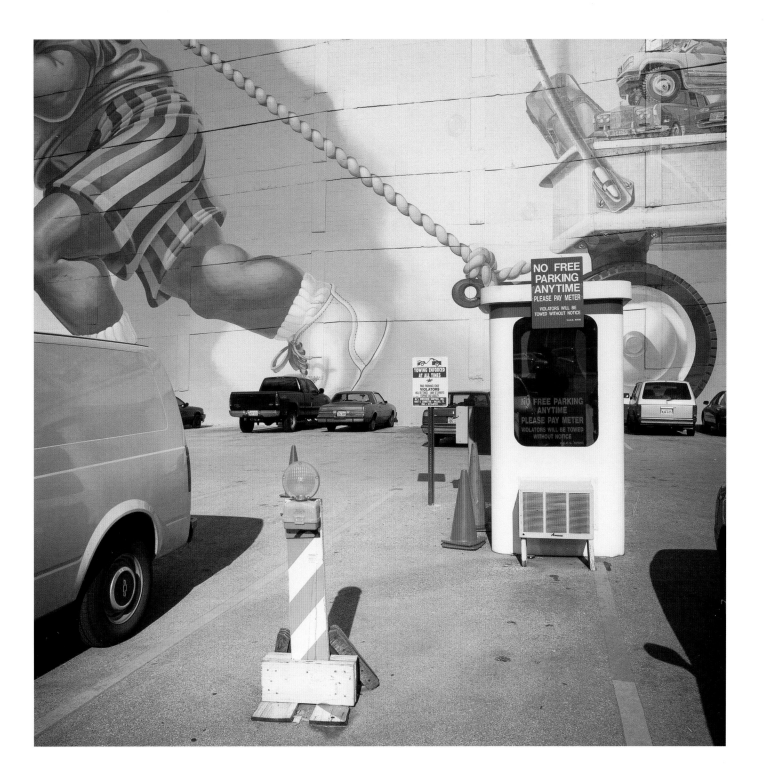

P-Star Parking, Dallas, Texas, 1997

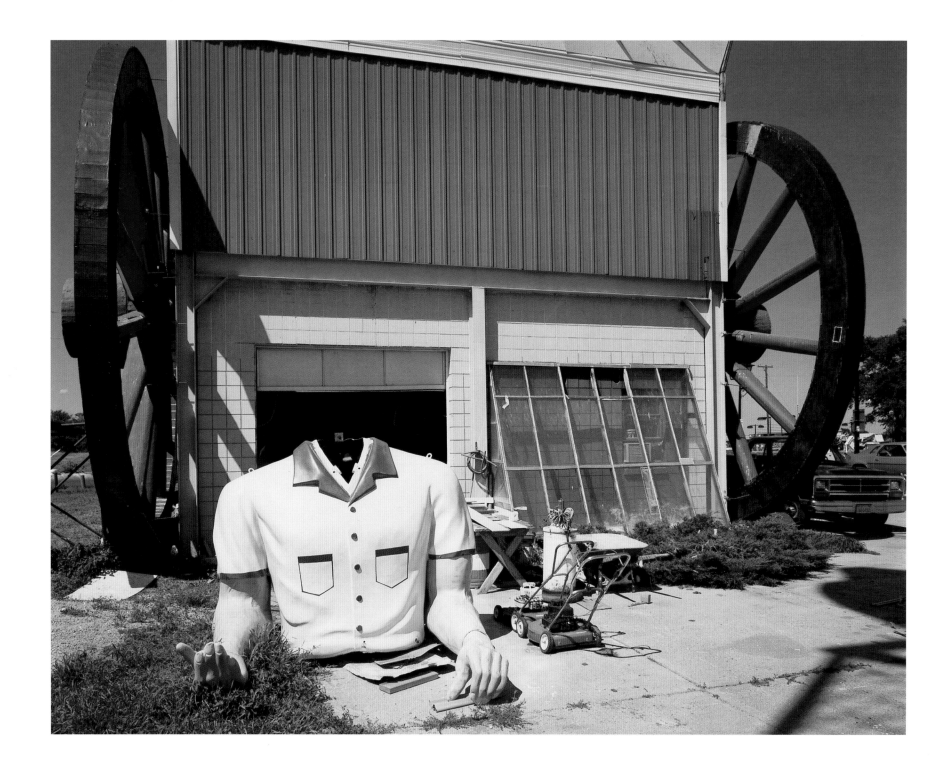

Dahle's 66, Route 70, Nebraska 1991

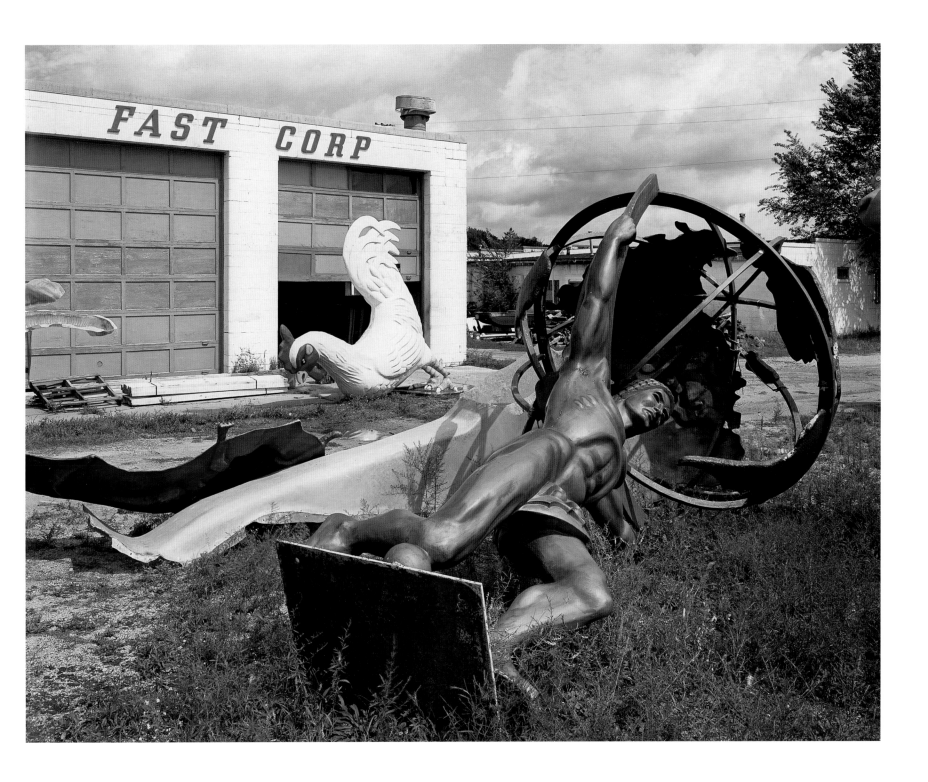

FAST Corp., Sparta, Wisconsin 1988

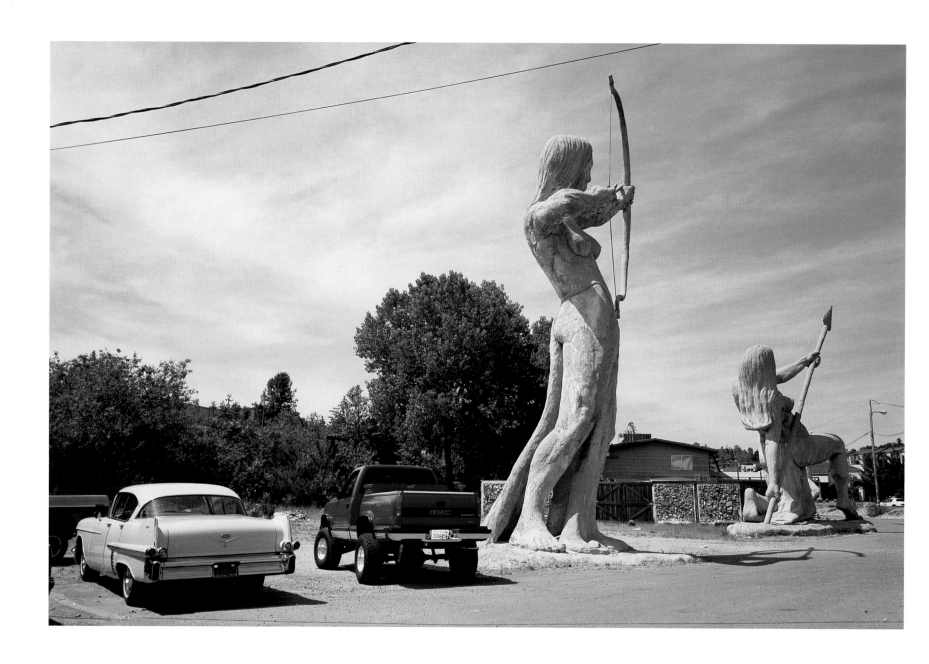

Sculptures by Kenneth Fox, D.D.S., Auburn, California 1992

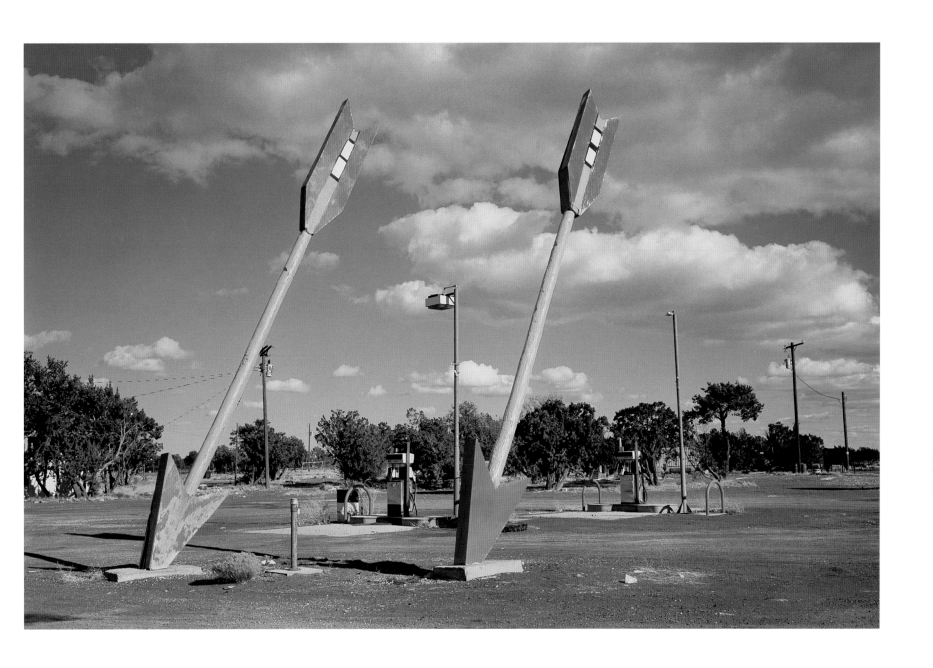

Twin Arrows, Arizona, 2001

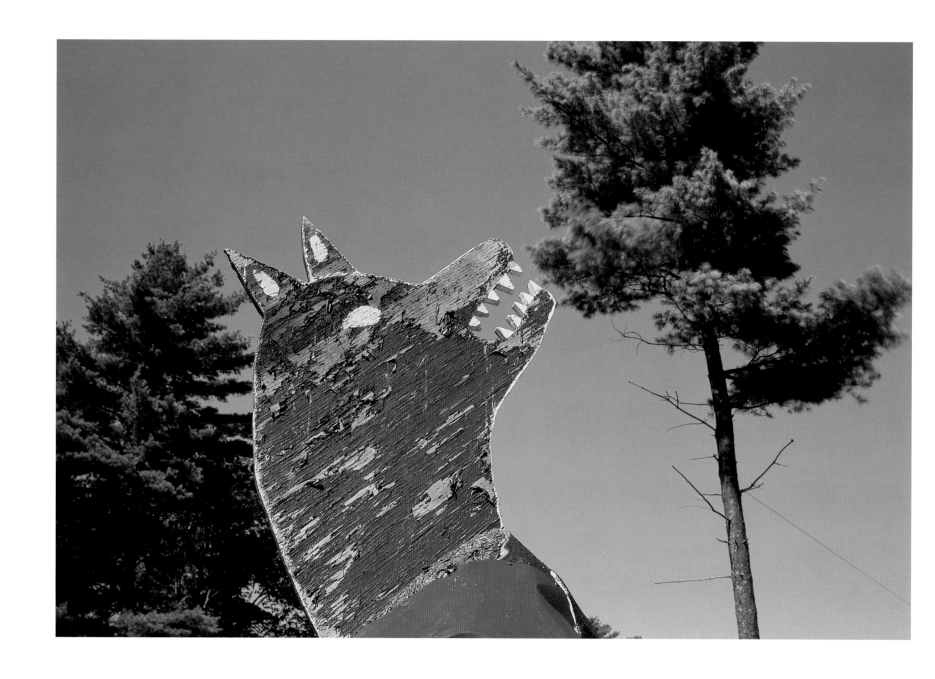

Bath, Maine, 1995

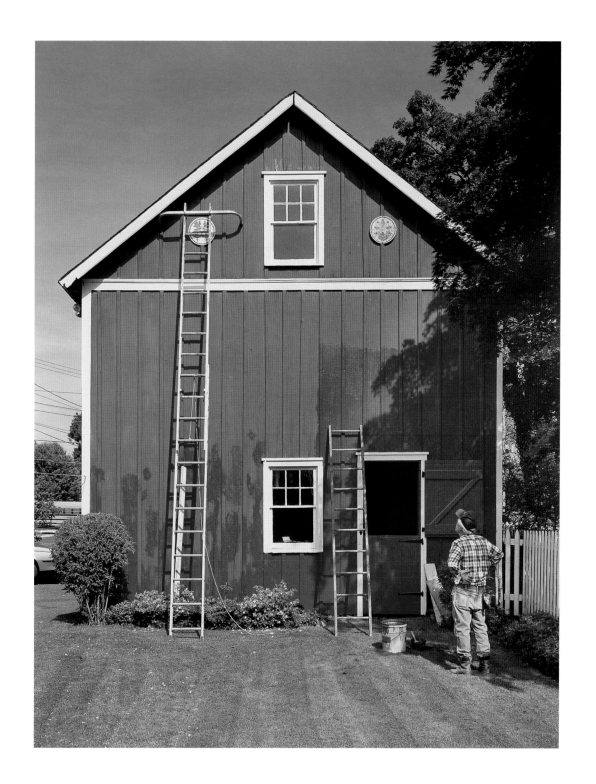

Mr. Fitzpatrick, Newtown, Pennsylvania 1993

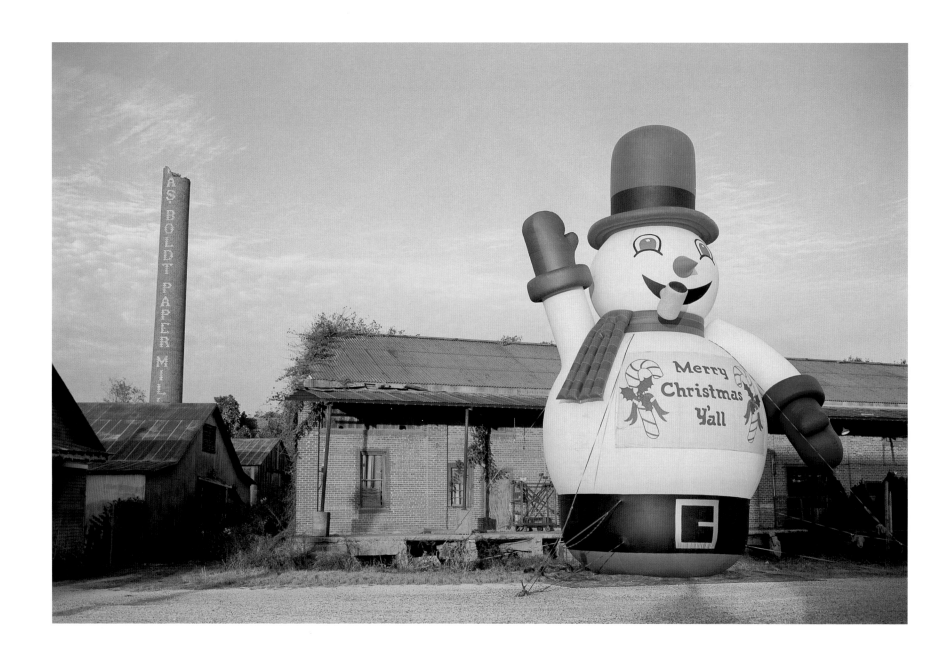

New Iberia, Louisiana 1995

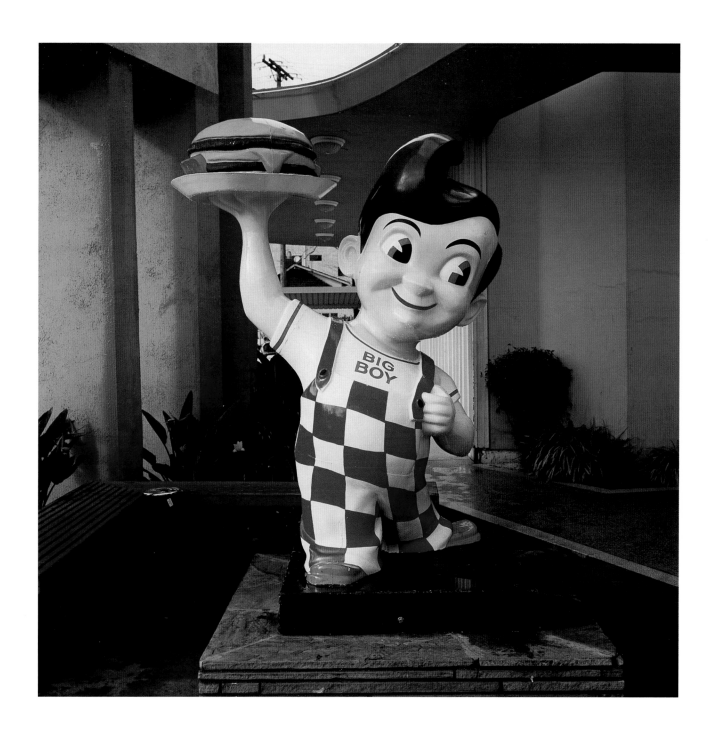

Bob's Big Boy, Burbank, California 2000

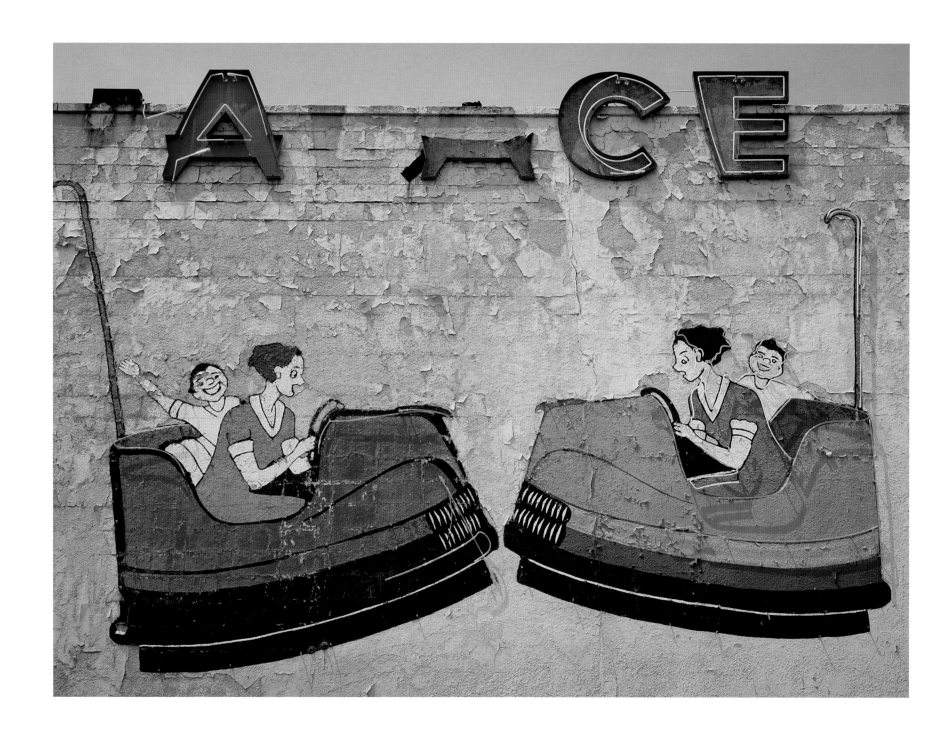

Asbury Park, New Jersey, 1996

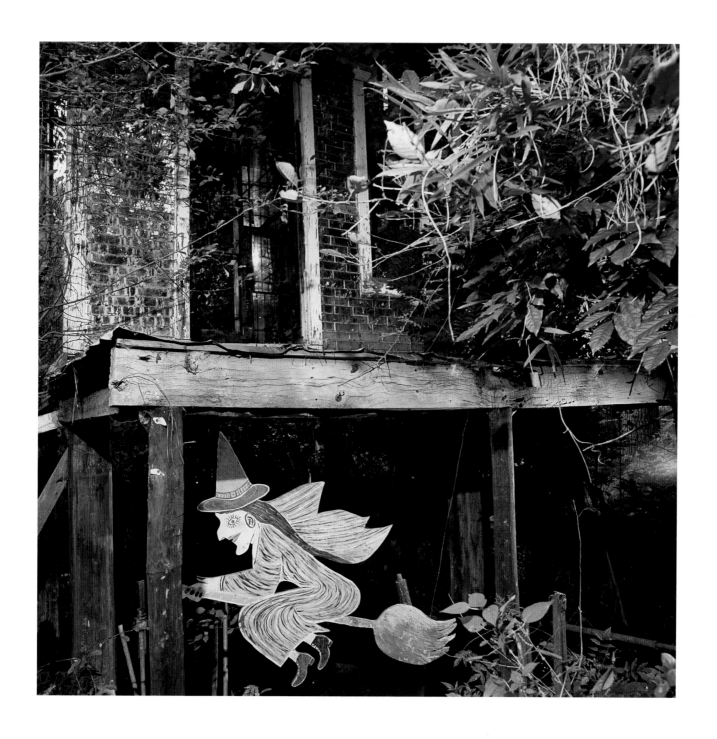

Howard Finster's Paradise Garden, Summerville, Georgia 1992

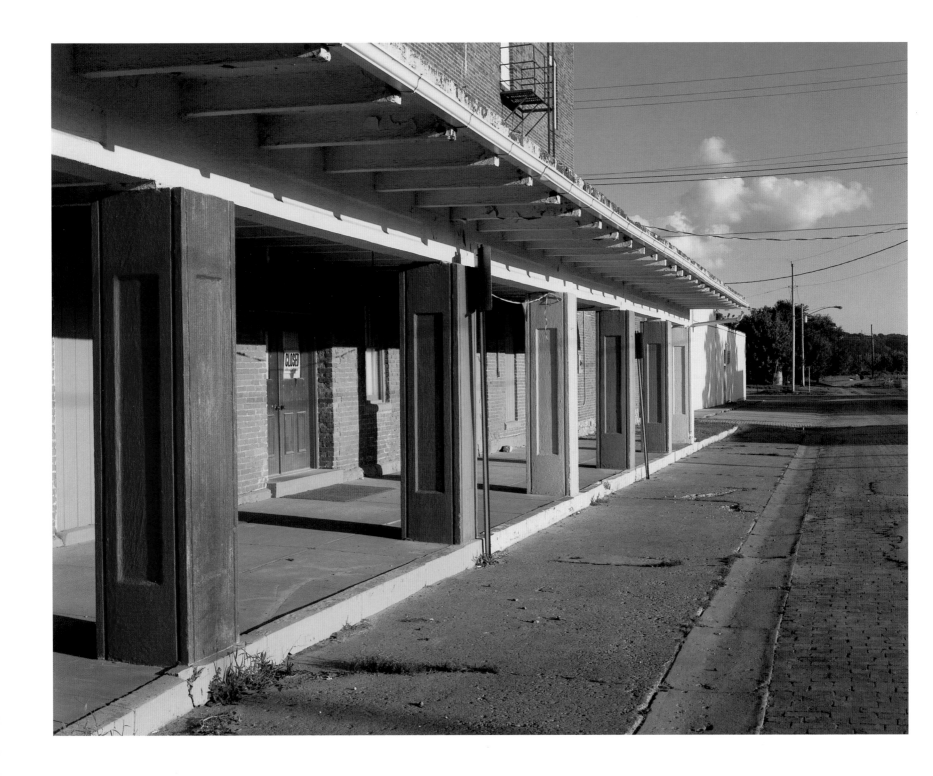

Fort Madison, Iowa 1993

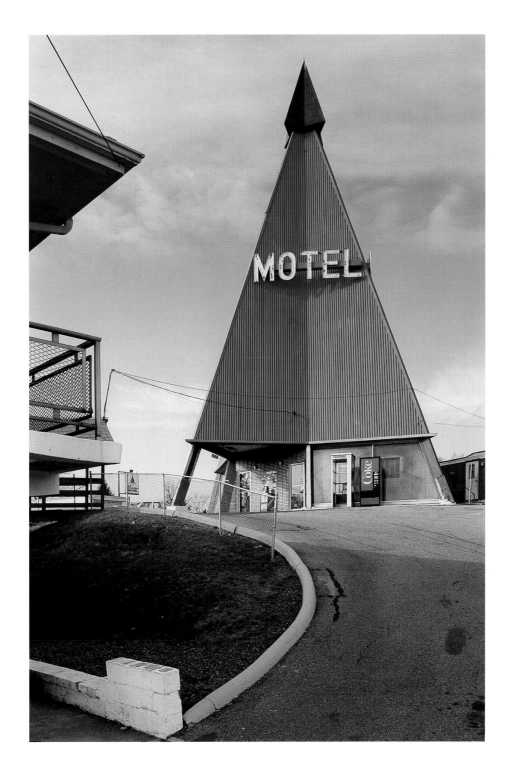

Pennview Motel, Reading, Pennsylvania 1995

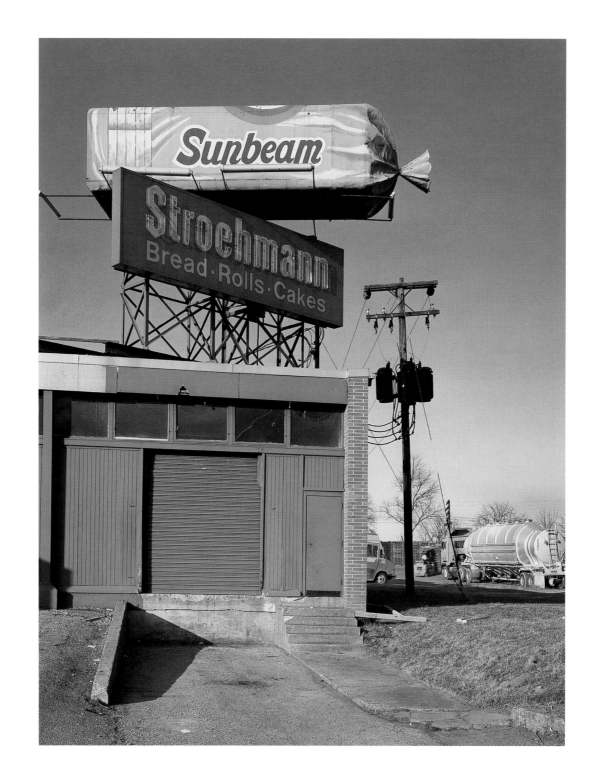

Stroehmann Bakery, Harrisburg, Pennsylvania 1993

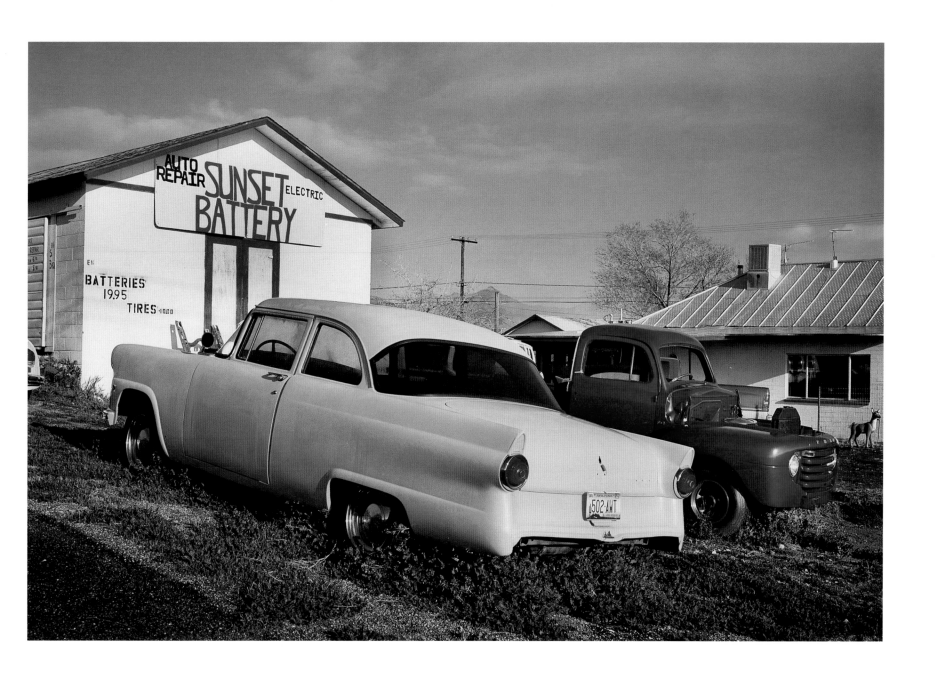

Kingman, Arizona 2001

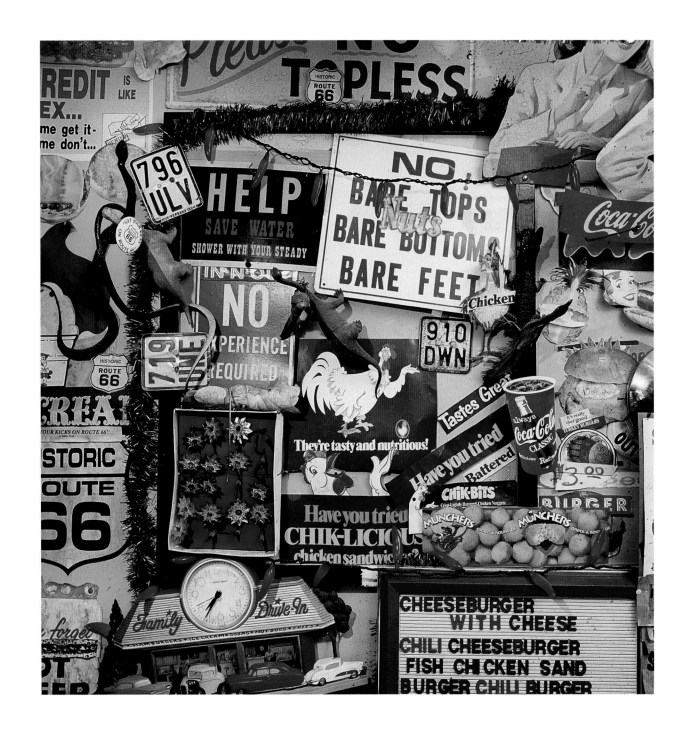

Delgadillo's Snow Cap, Seligman, Arizona 2001

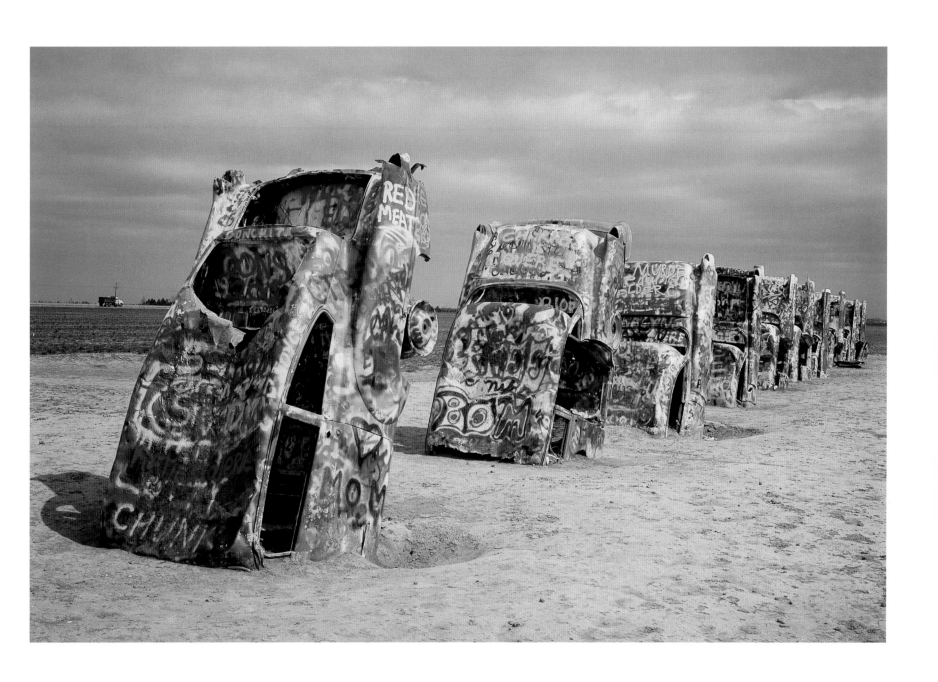

Amarillo, Texas 2001

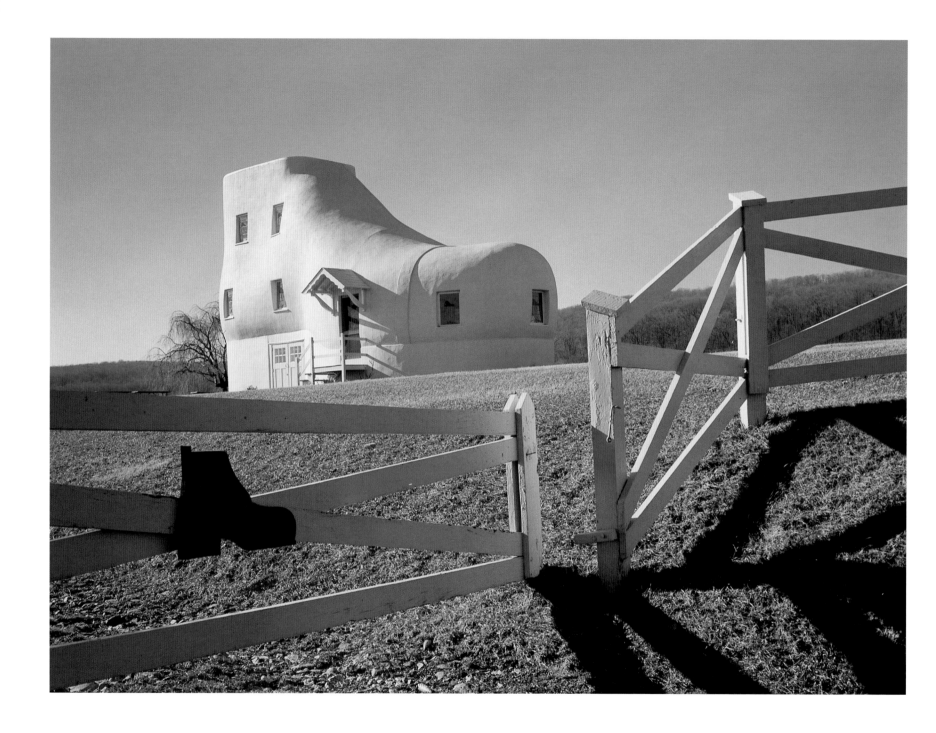

Hallam, Pennsylvania 1995

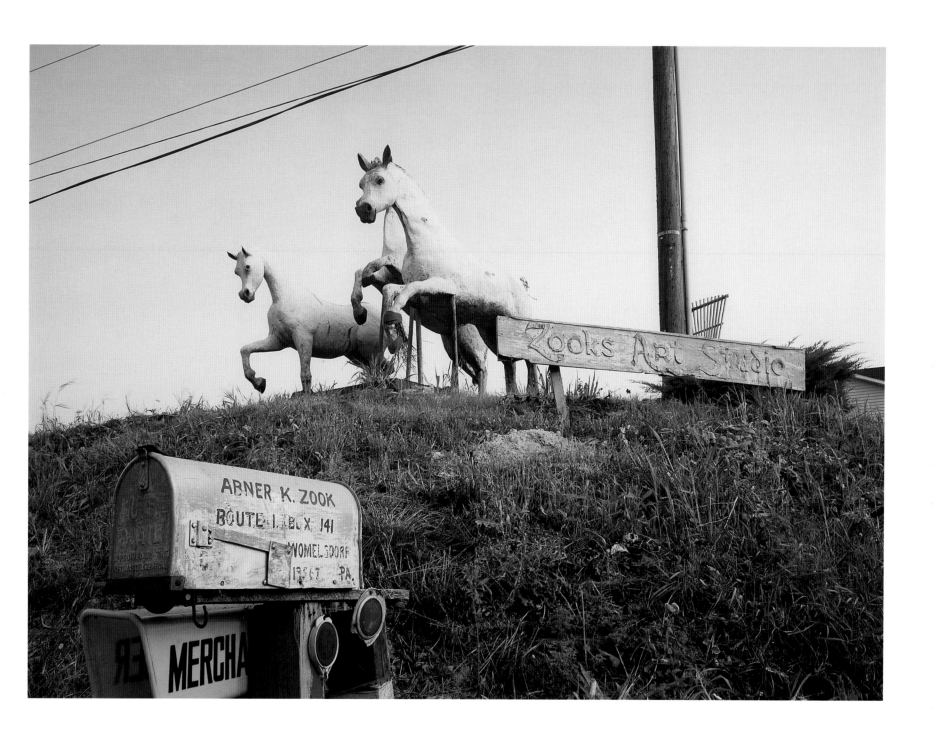

Womelsdorf, Pennsylvania 1995

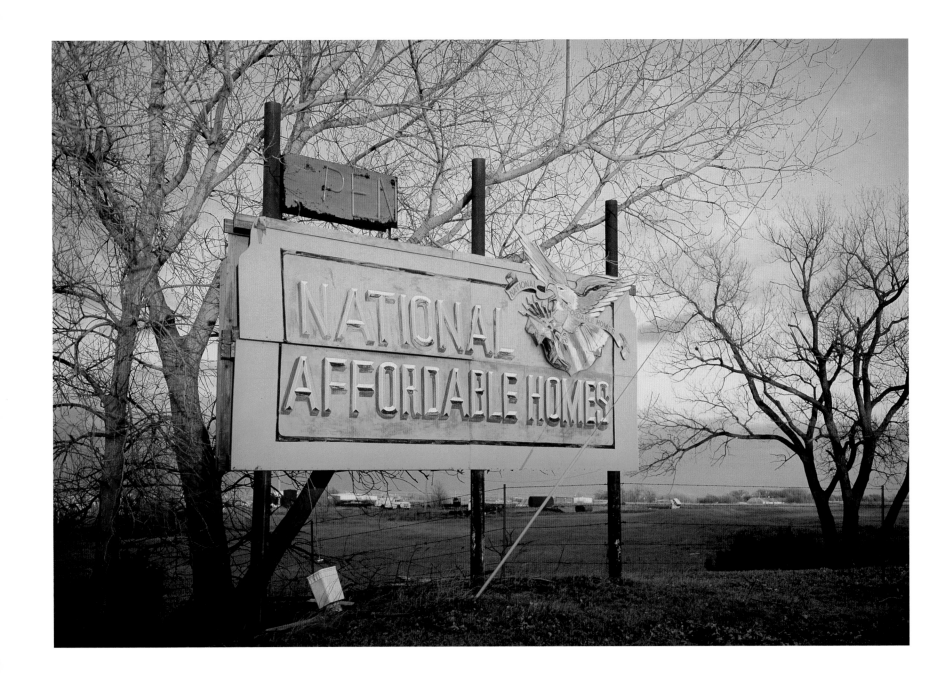

Elk City, Oklahoma 2001

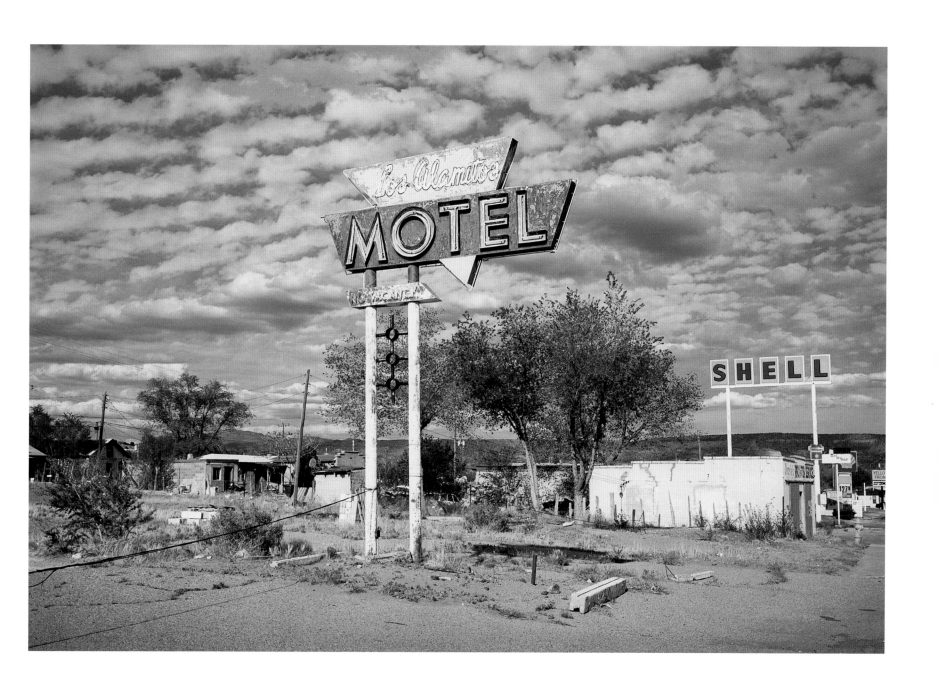

Grants, New Mexico 1995

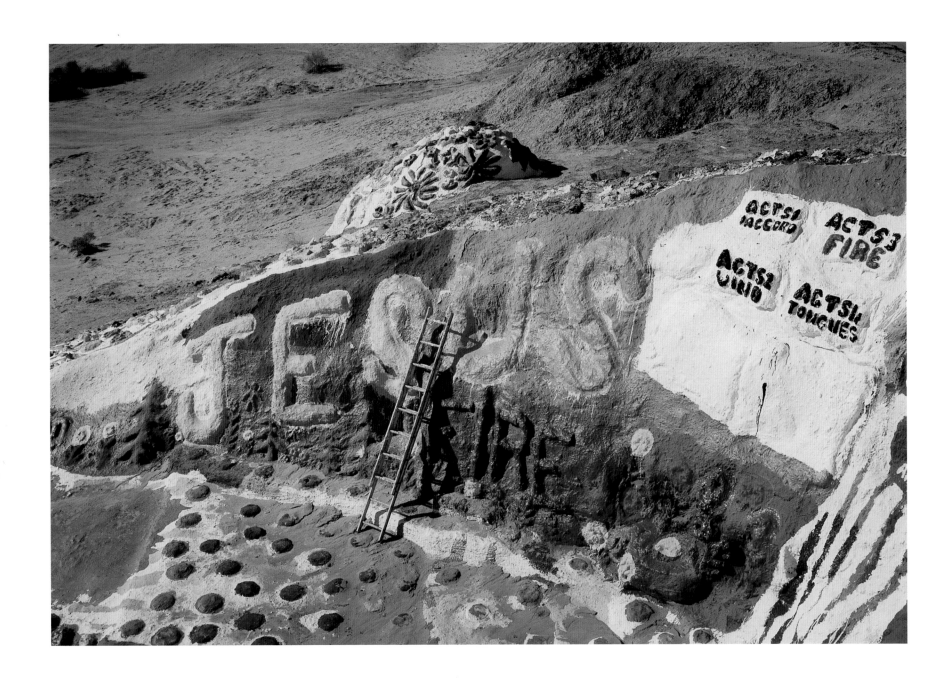

Leonard Knight's Salvation Mountain, Niland, California 2000

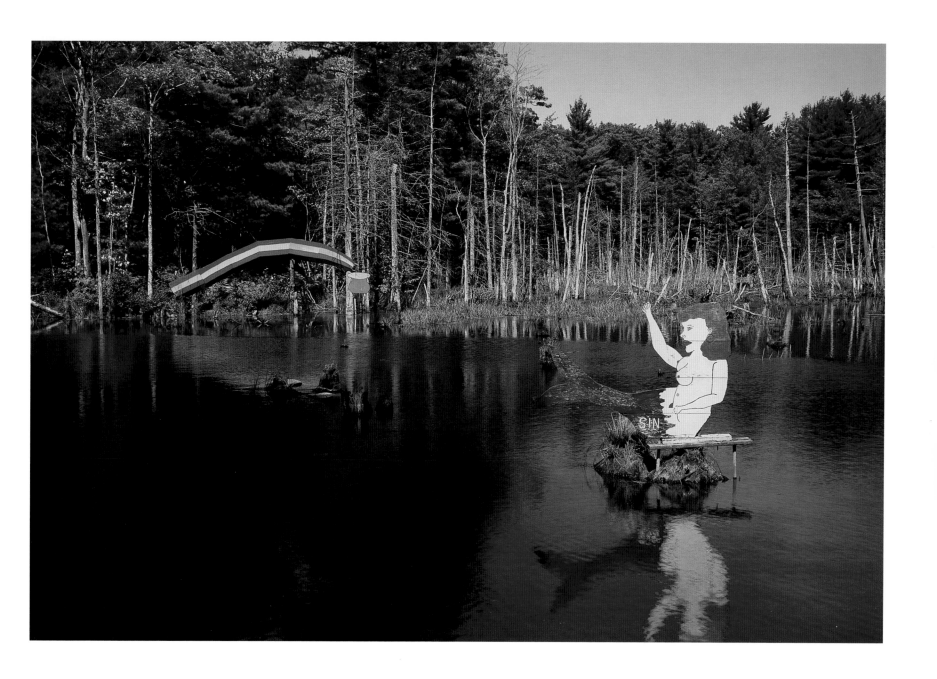

Bath, Maine 1995

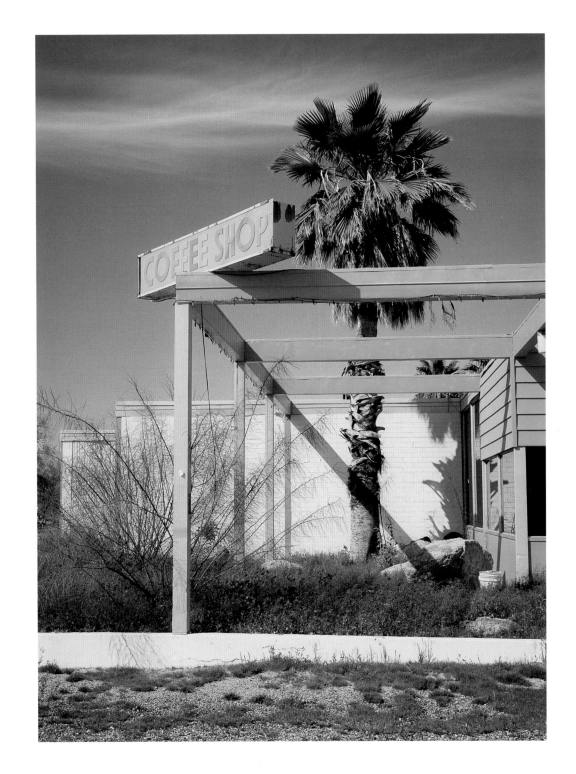

South of Phoenix, Arizona 1993

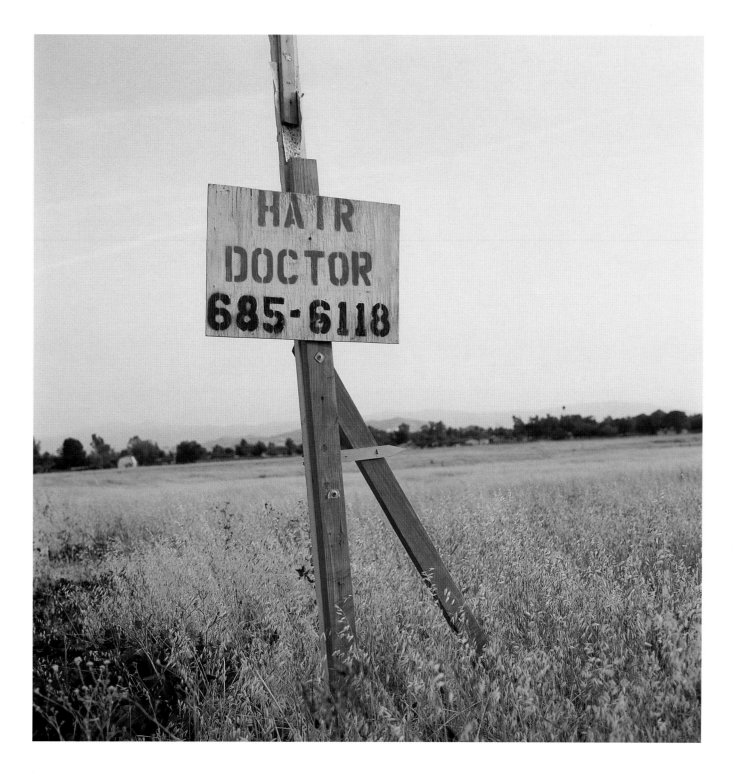

Glen Avon, California 1995

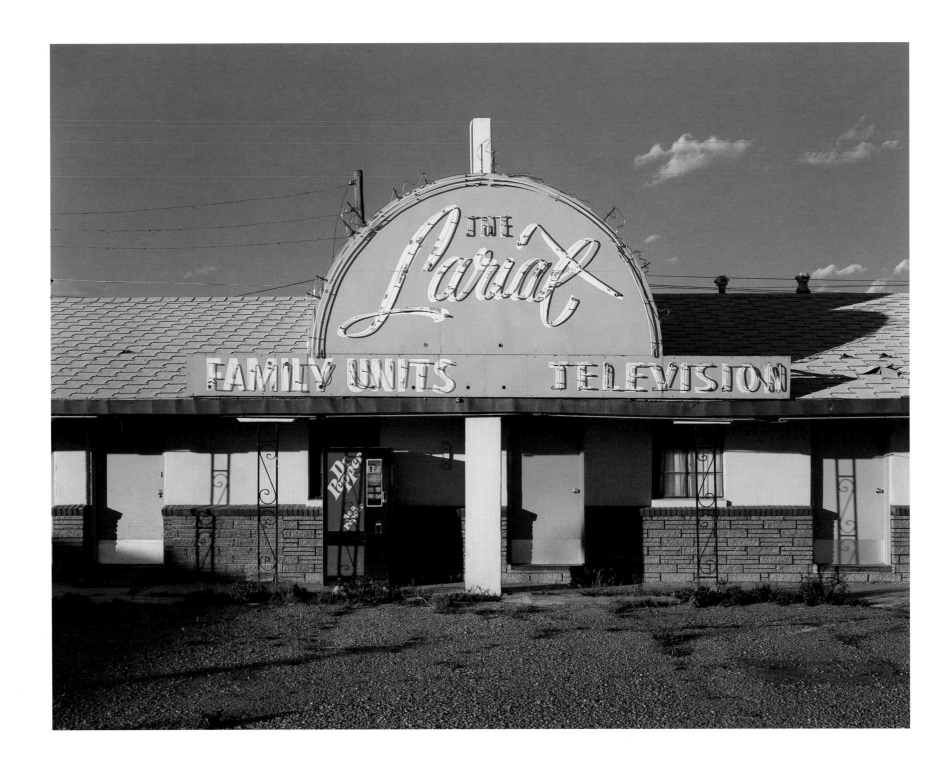

Grants, New Mexico 1989

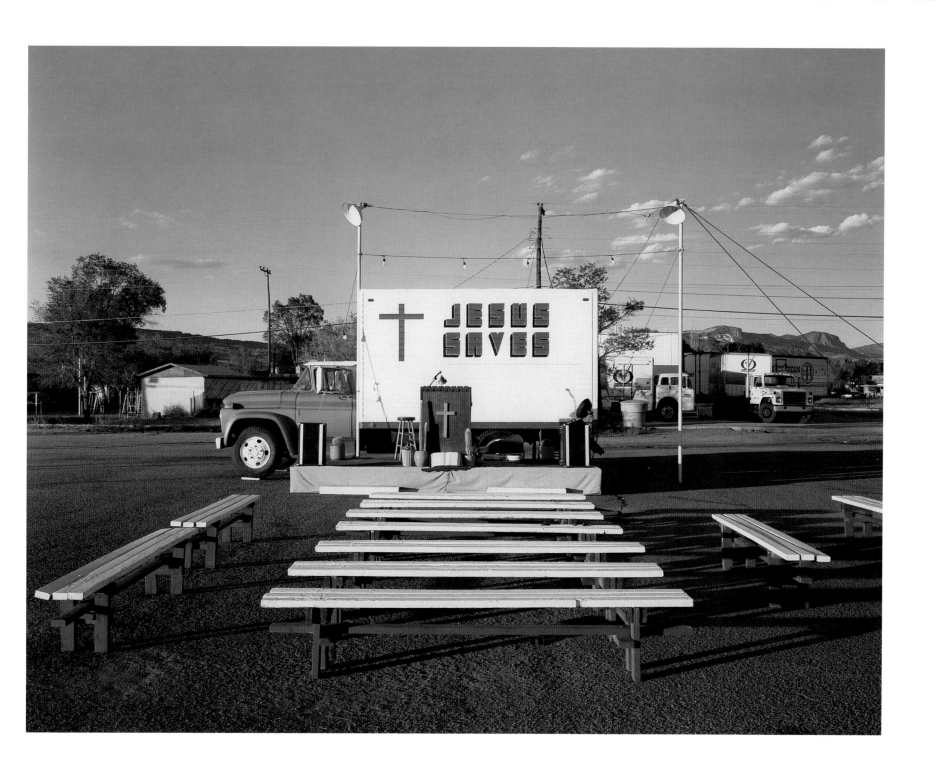

Grants, New Mexico 1989

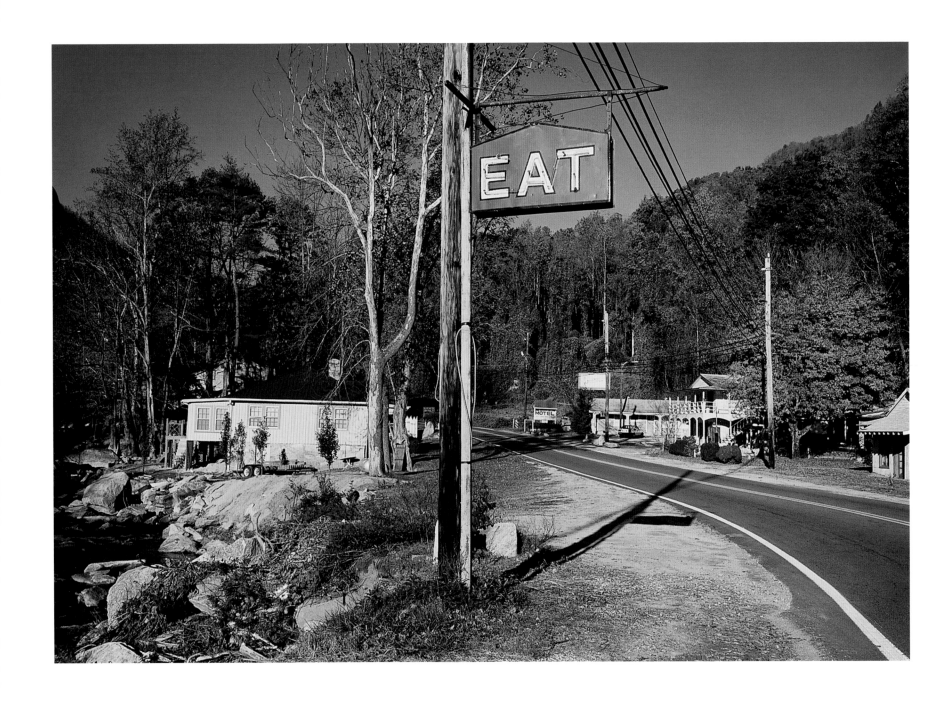

Chimney Rock, North Carolina 1996

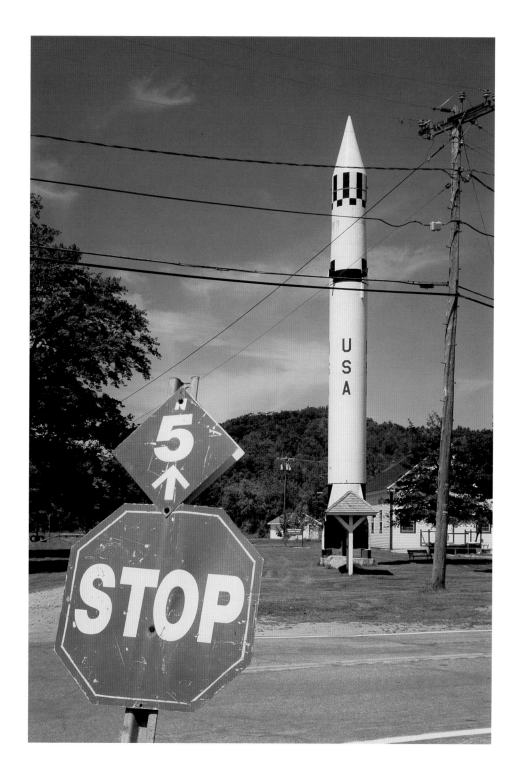

Redstone Rocket, Warren, New Hampshire 1999

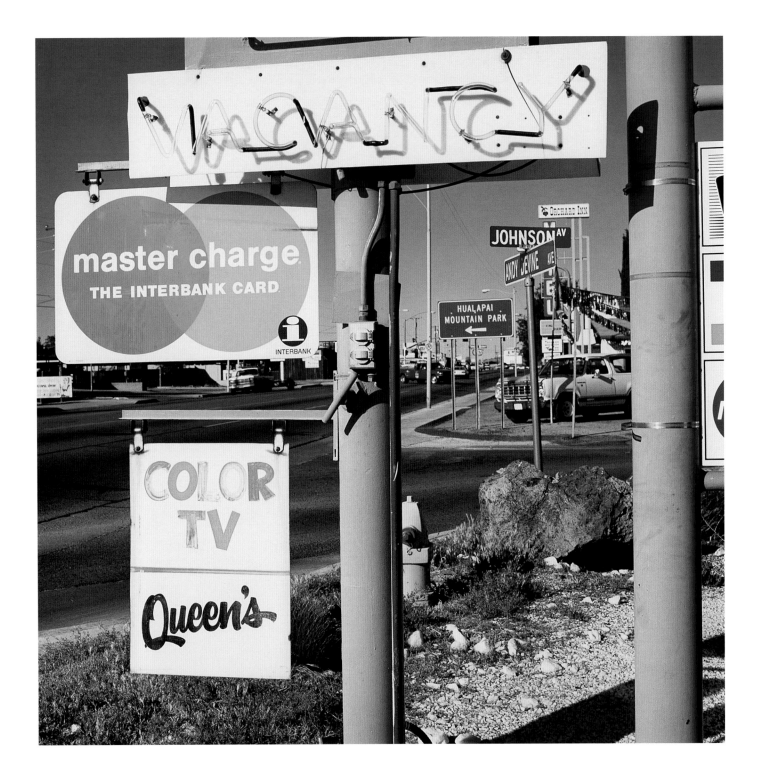

Kingman, Arizona 1995

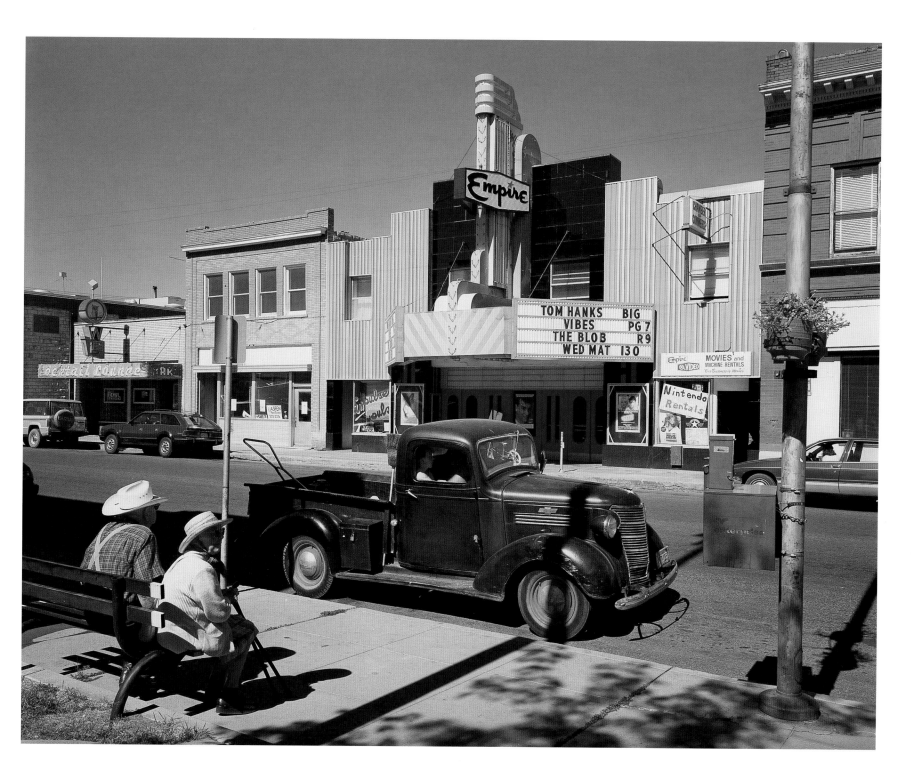

Livingston, Montana 1988

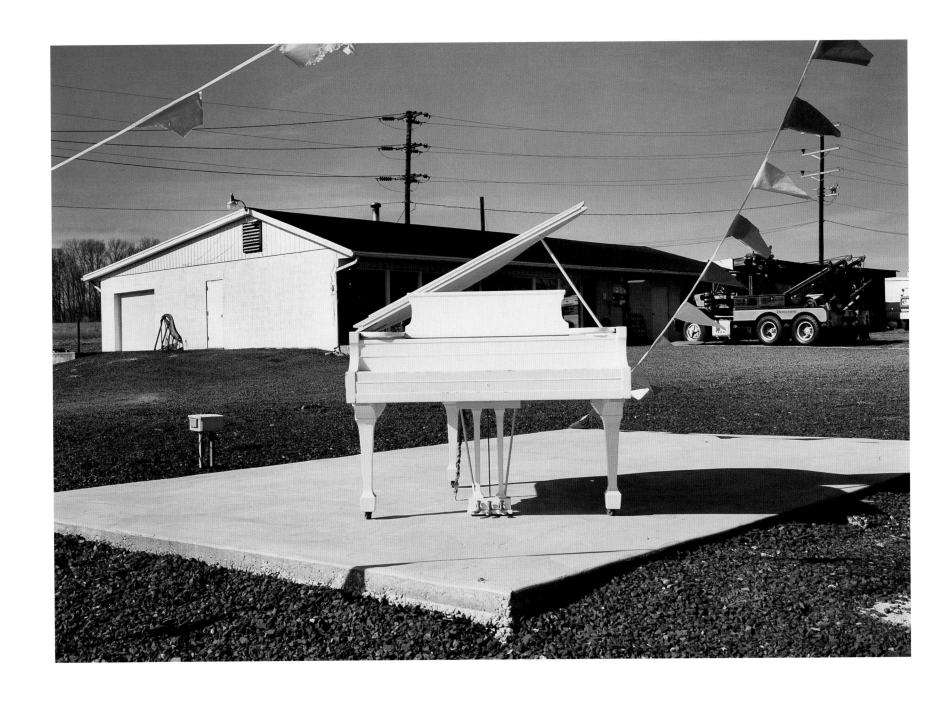

Music Store, North of Quakertown, Pennsylvania 1991

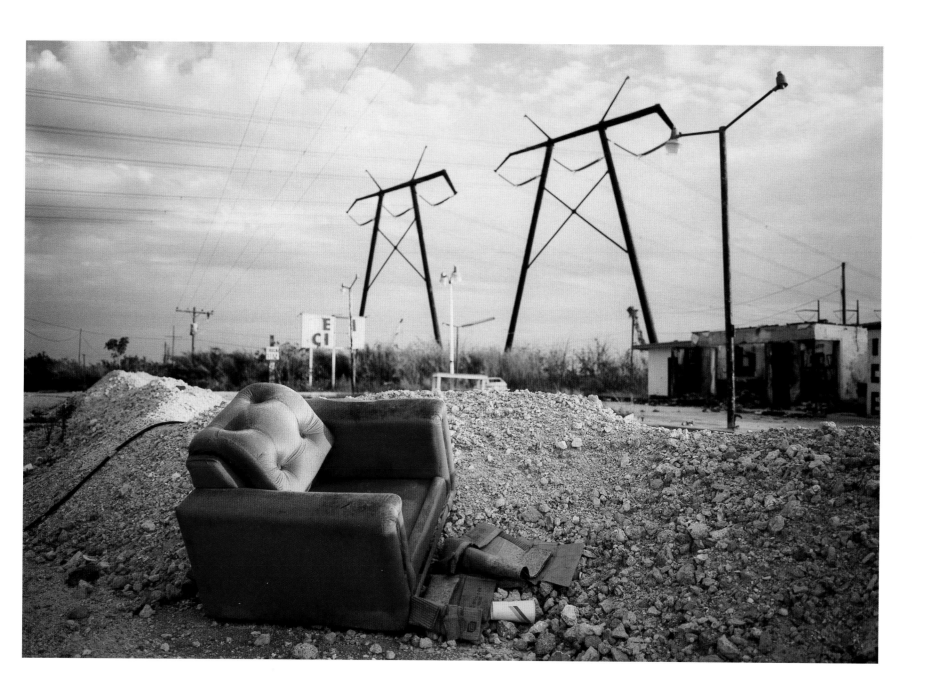

Florida, 1991

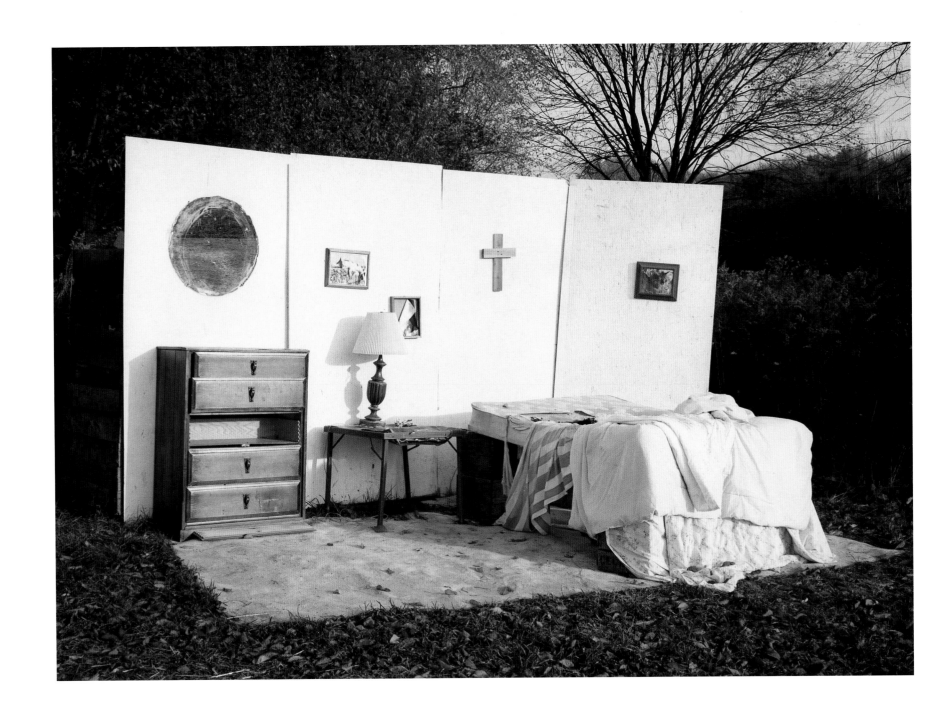

Solly Brother's Farm, Richboro, Pennsylvania 1999

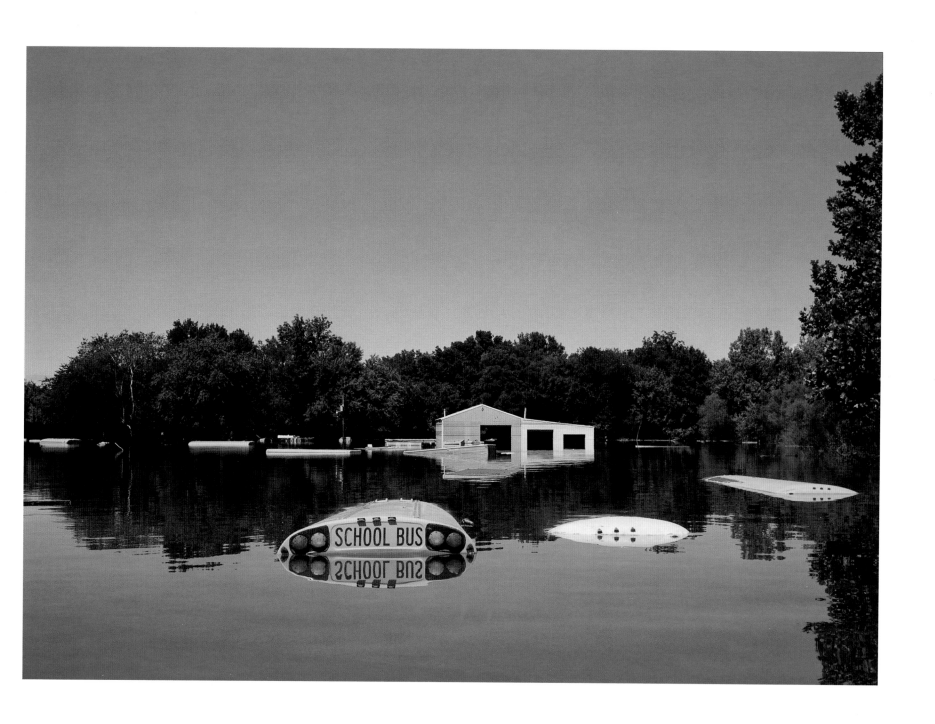

West Quincy, Missouri 1993

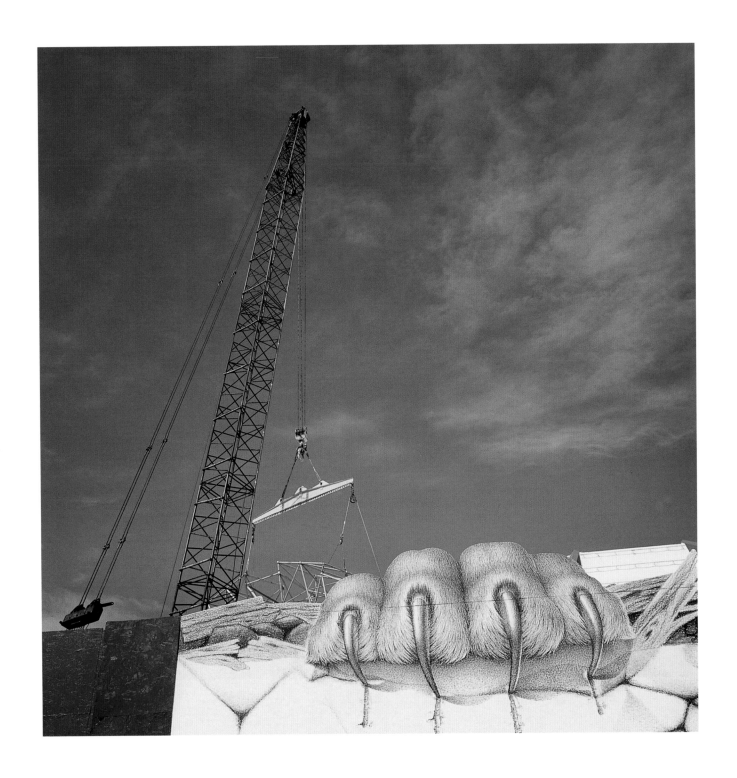

MGM Grand, Las Vegas, Nevada 1993

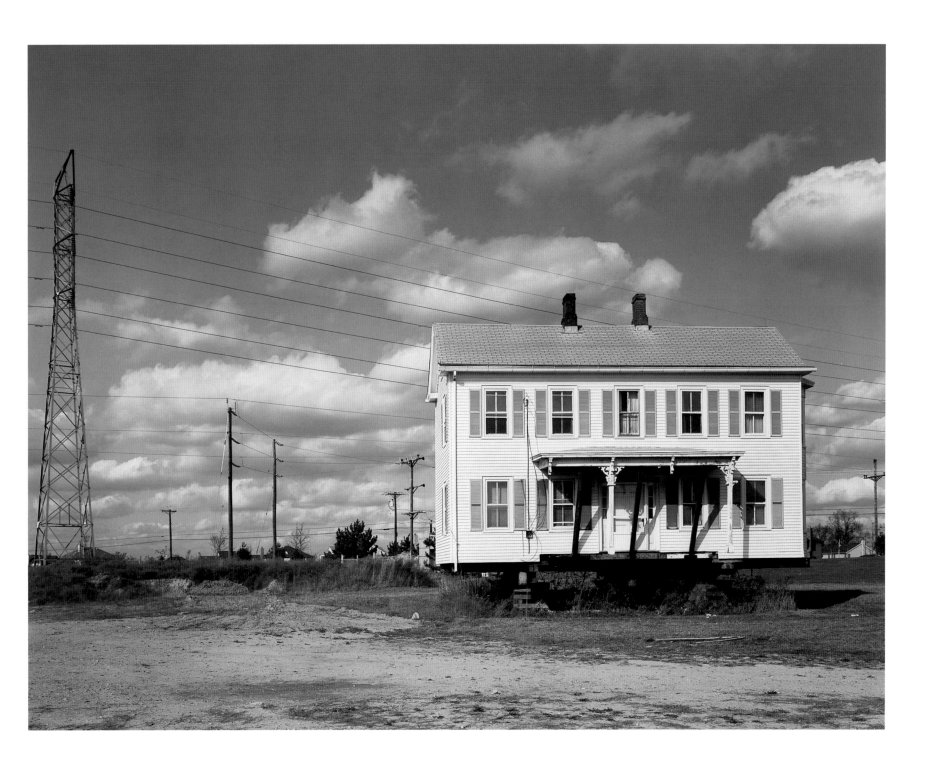

Ewing, New Jersey 1991

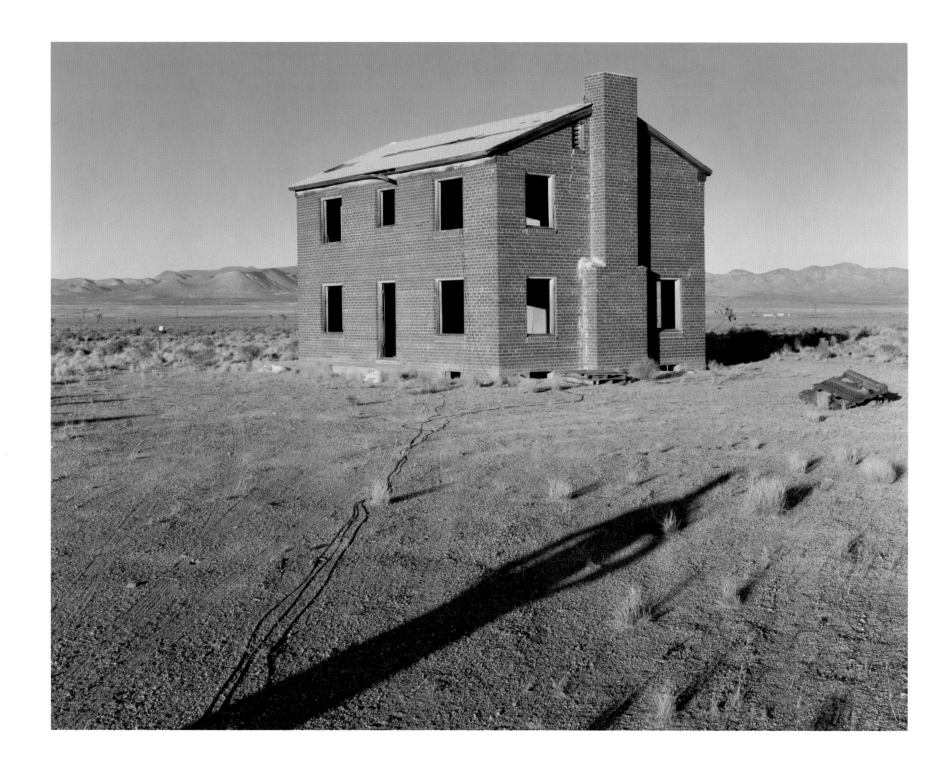

Survival Town, Yucca Flat, Nevada Test Site, Nevada 1988

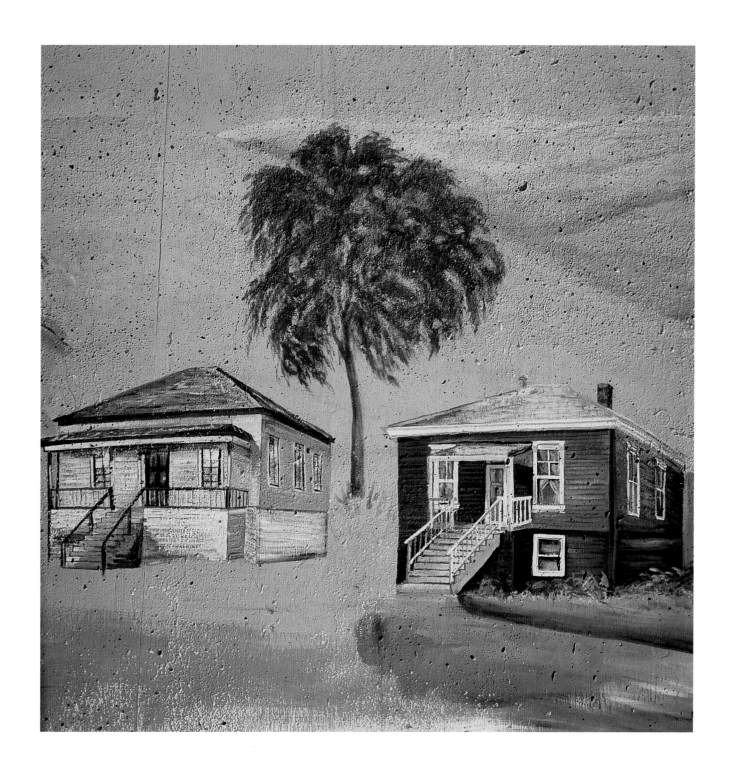

Near Richmond, California 1995

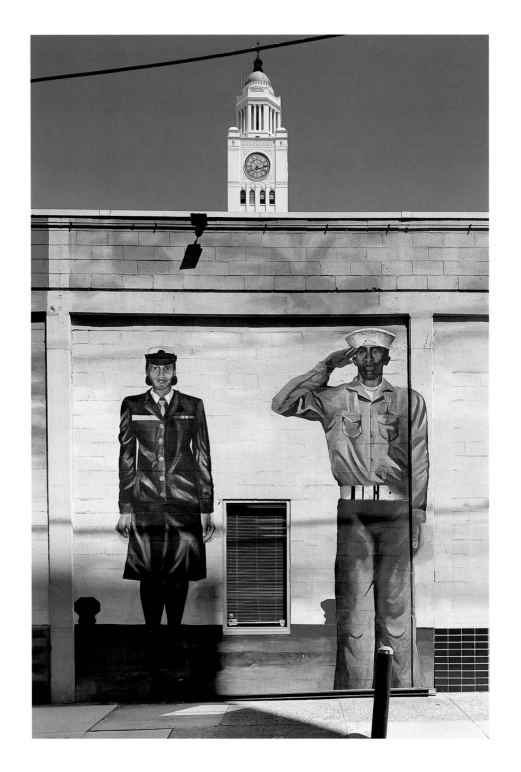

Philadelphia, Pennsylvania 1994

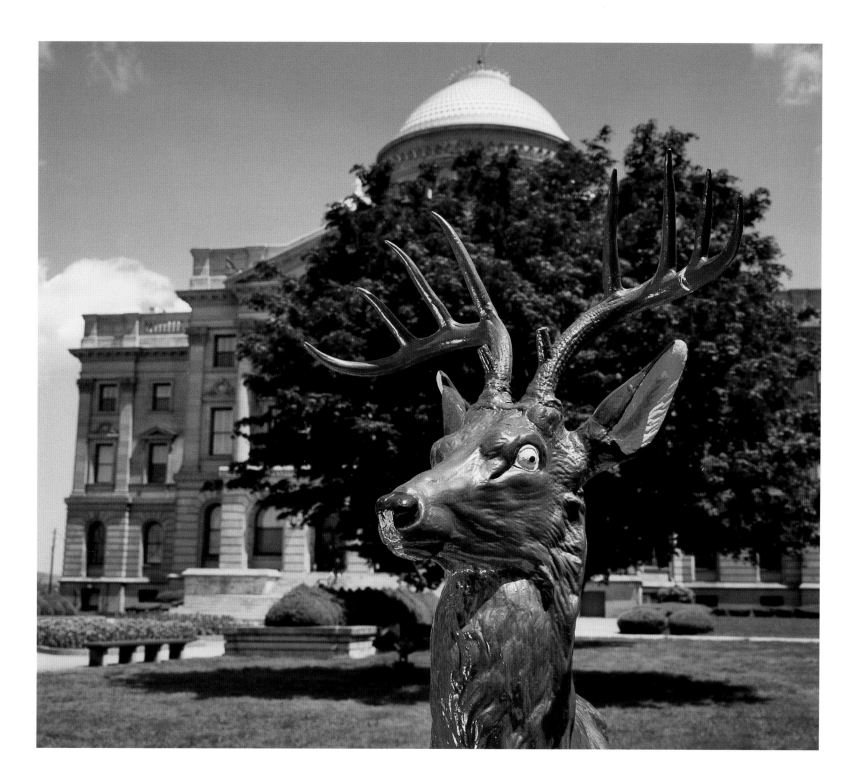

Scranton, Pennsylvania 1996

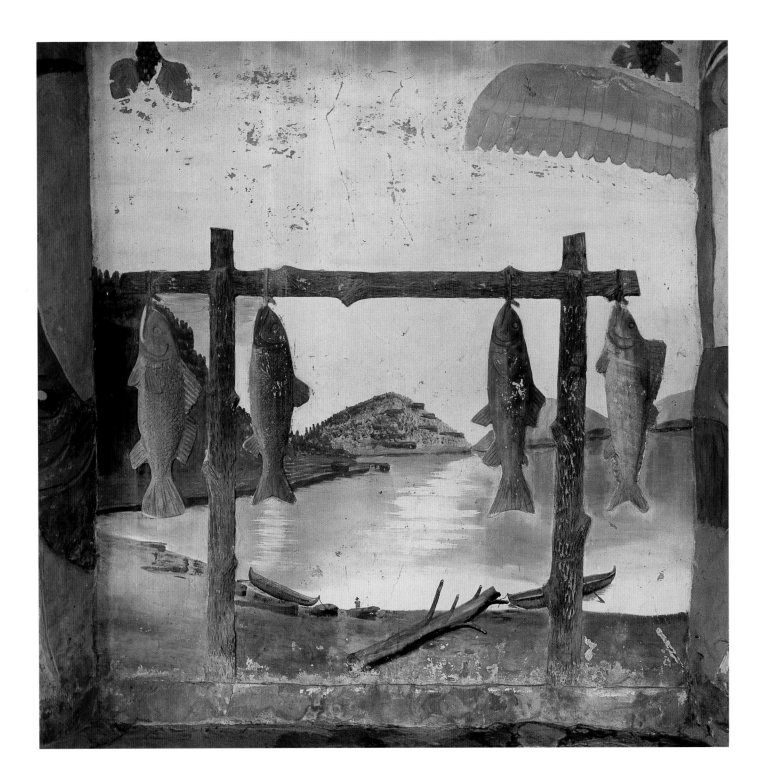

Ed Galloway's Totem Pole Park, Foyil, Oklahoma 2001

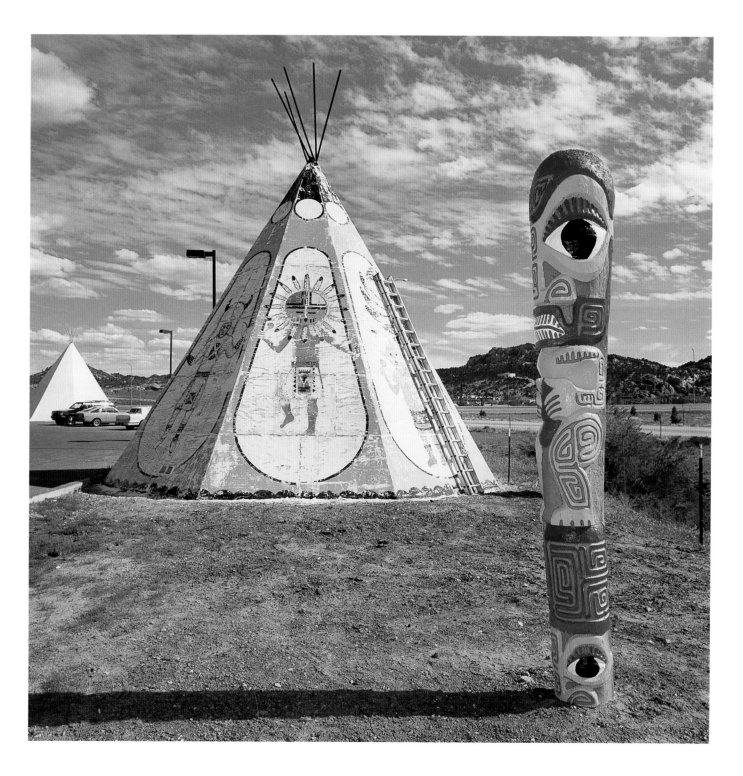

Gallup, New Mexico 1995

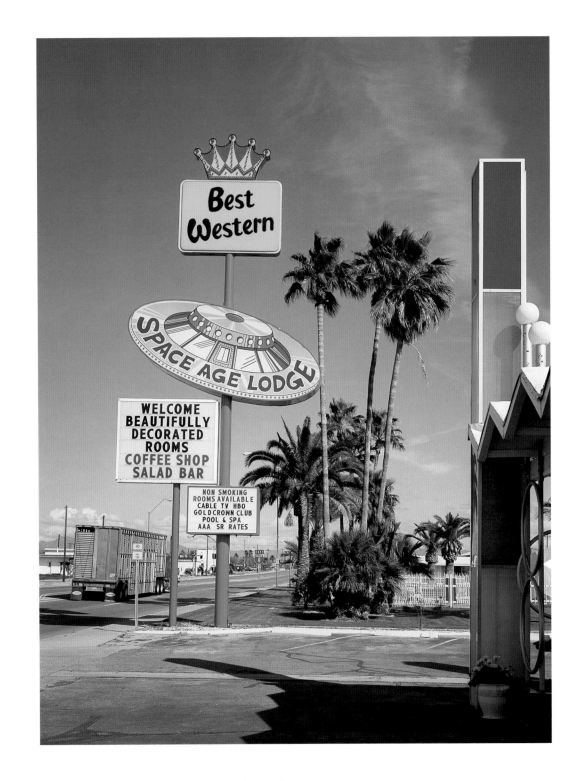

Gila Bend, Arizona 1993

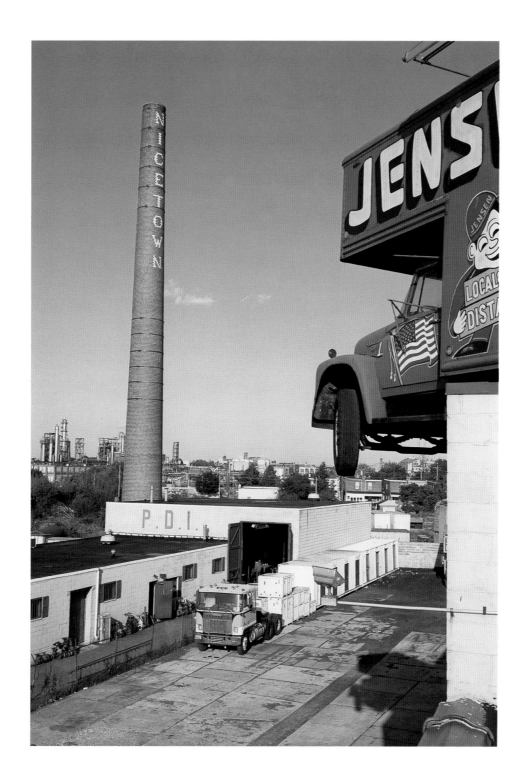

Jensen Moving, Nicetown, Philadelphia, Pennsylvania 1992

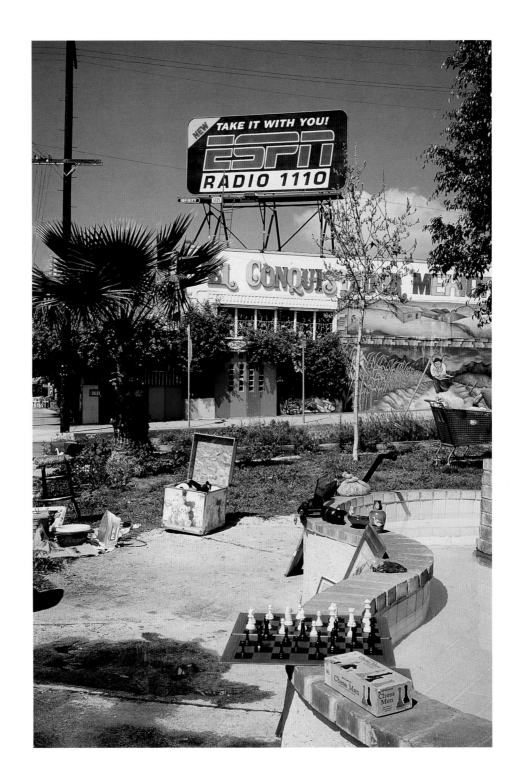

Sunset Blvd & Edgecliff, Los Angeles, California 2001

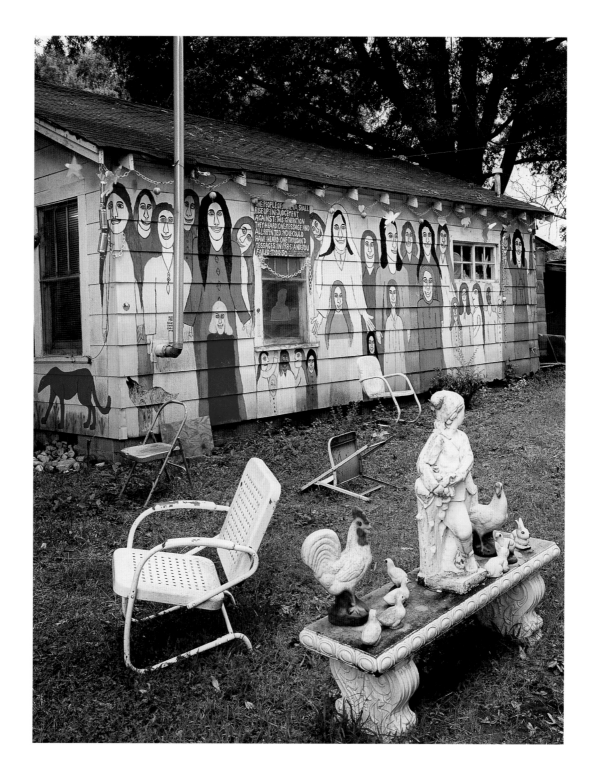

Howard Finster's Paradise Garden, Summerville, Georgia 1992

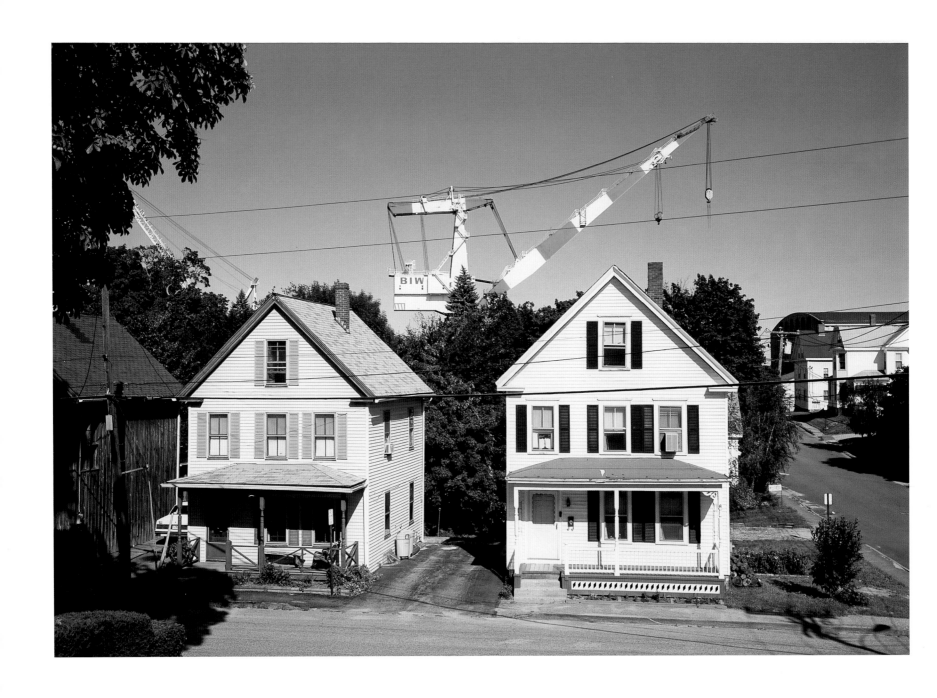

Bath Iron Works, Bath, Maine 1995

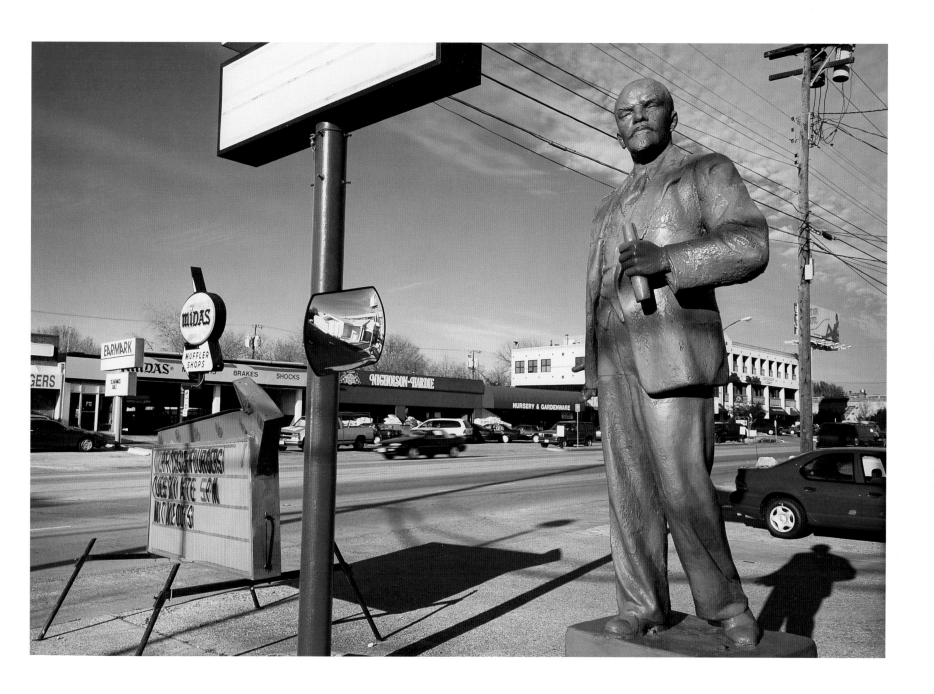

Lenin, Gott's Hamburgers, Lover's Lane, Dallas, Texas 1997

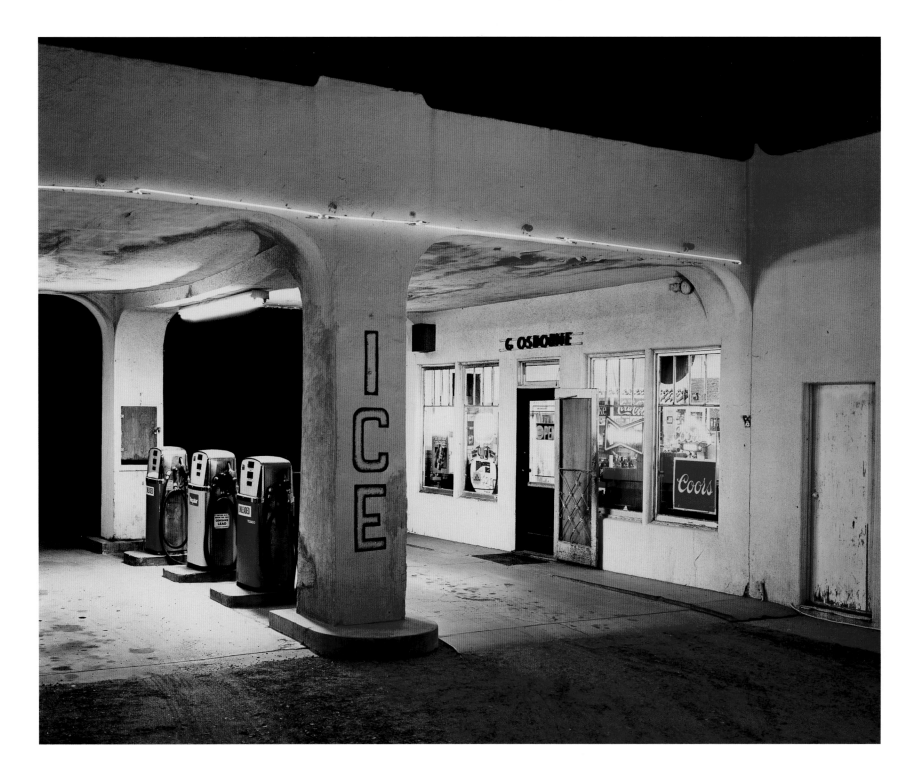

Casa Grande, Arizona 1986

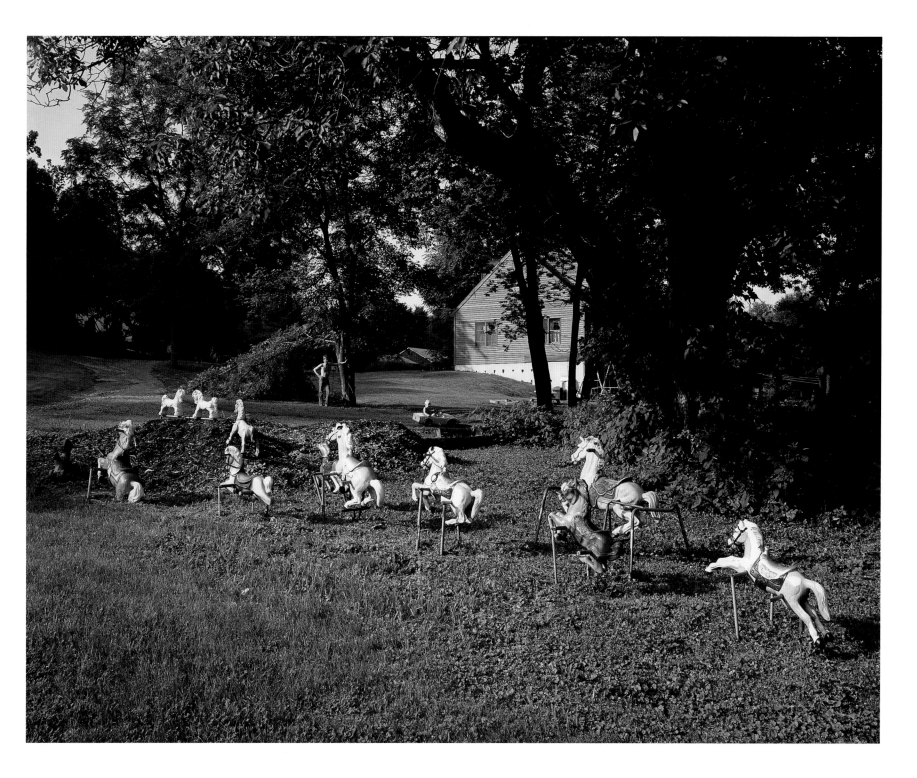

Daniel and Alan Warner, Easton, Pennsylvania 1989

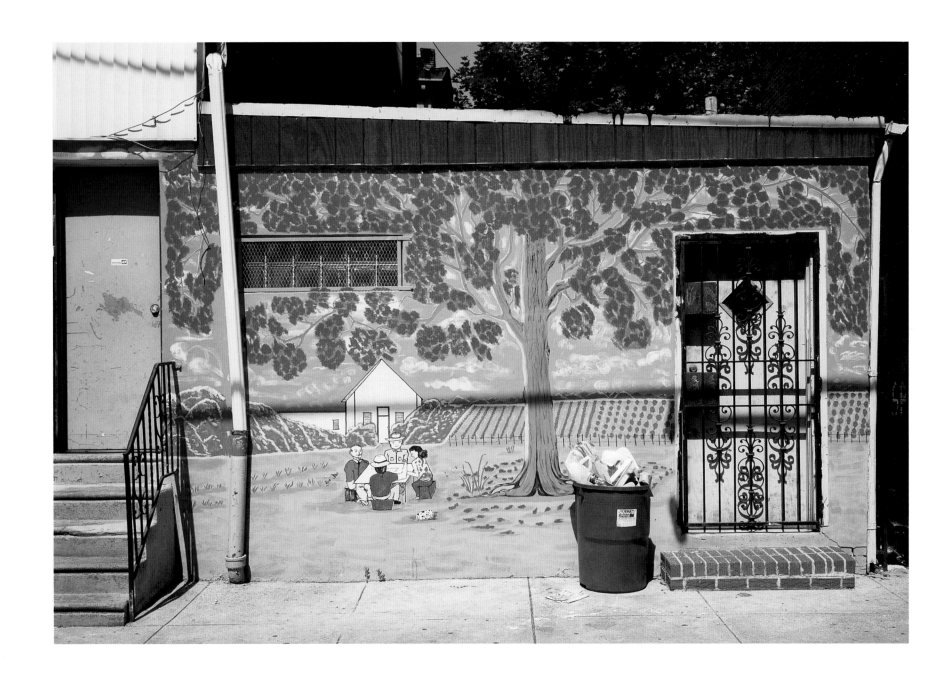

Philadelphia, Pennsylvania 2000

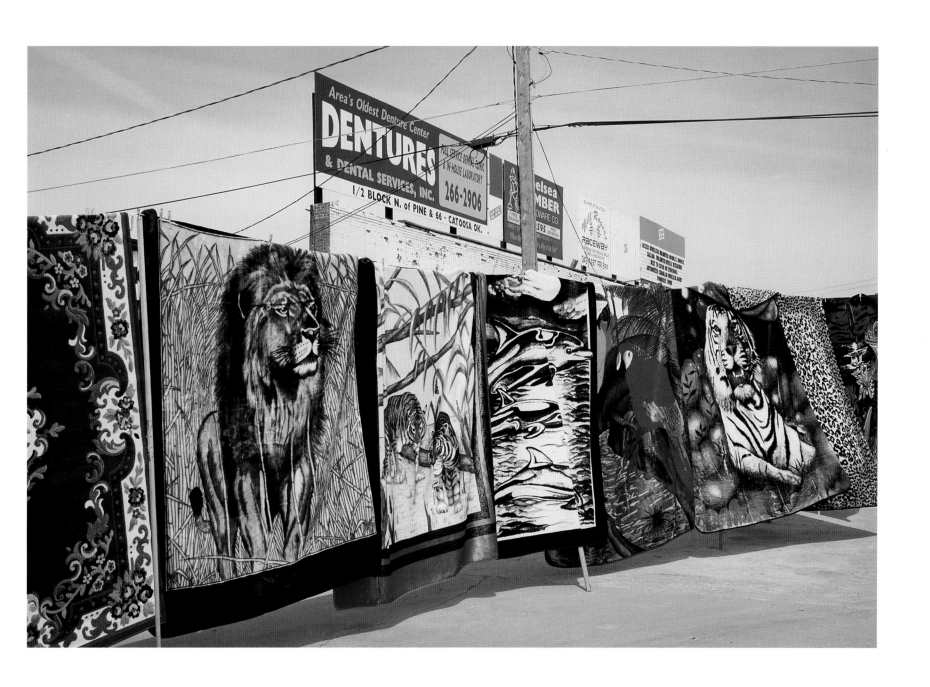

Earl Ward's Rug Stand, Claremore, Missouri 2001

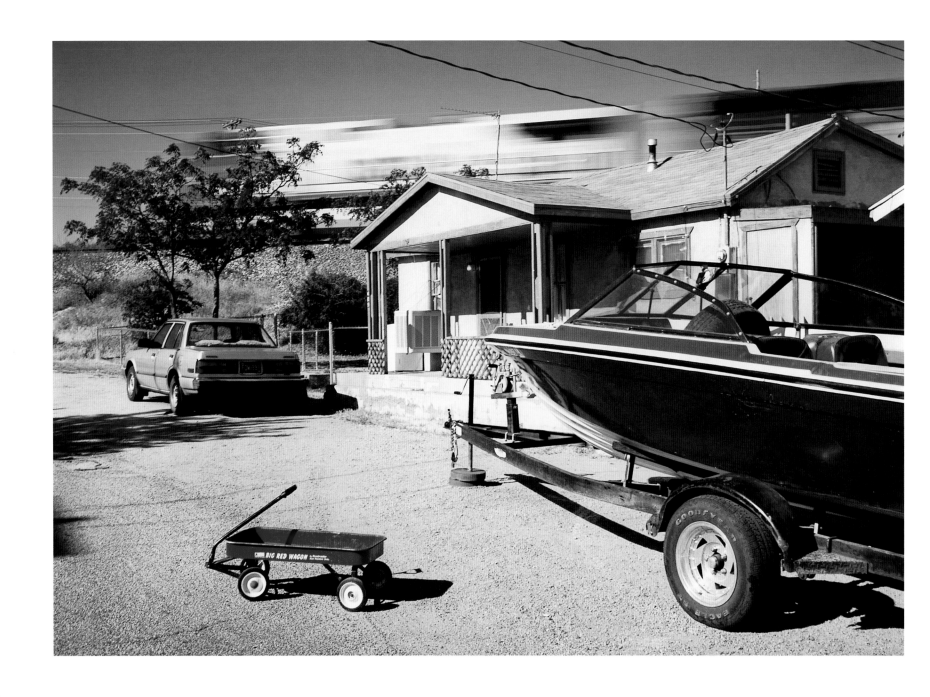

Santa Fe Train, Kingman, Arizona 1995

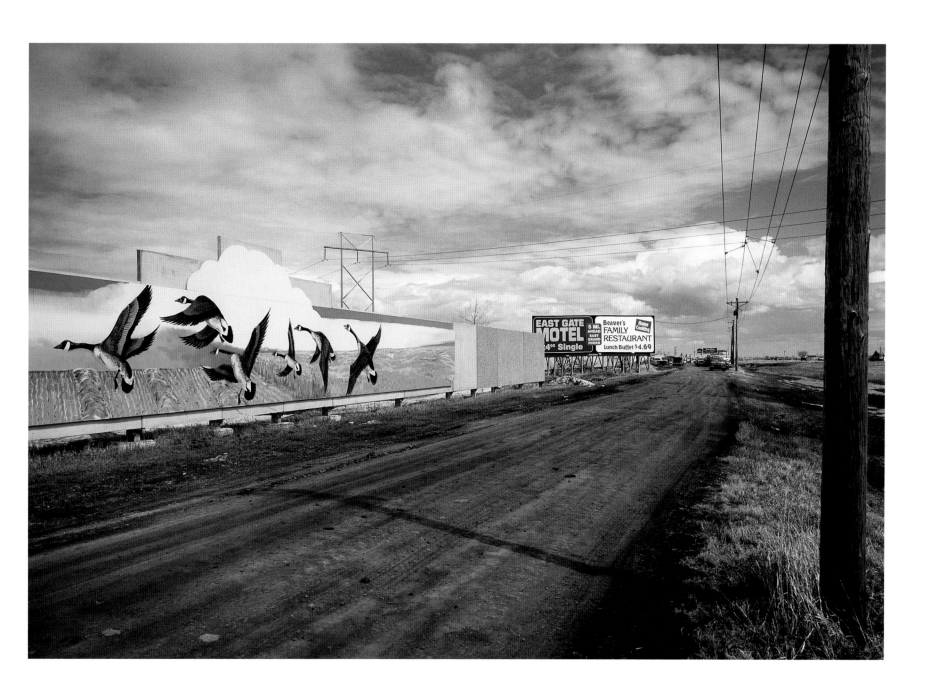

Grand Forks, North Dakota 1997

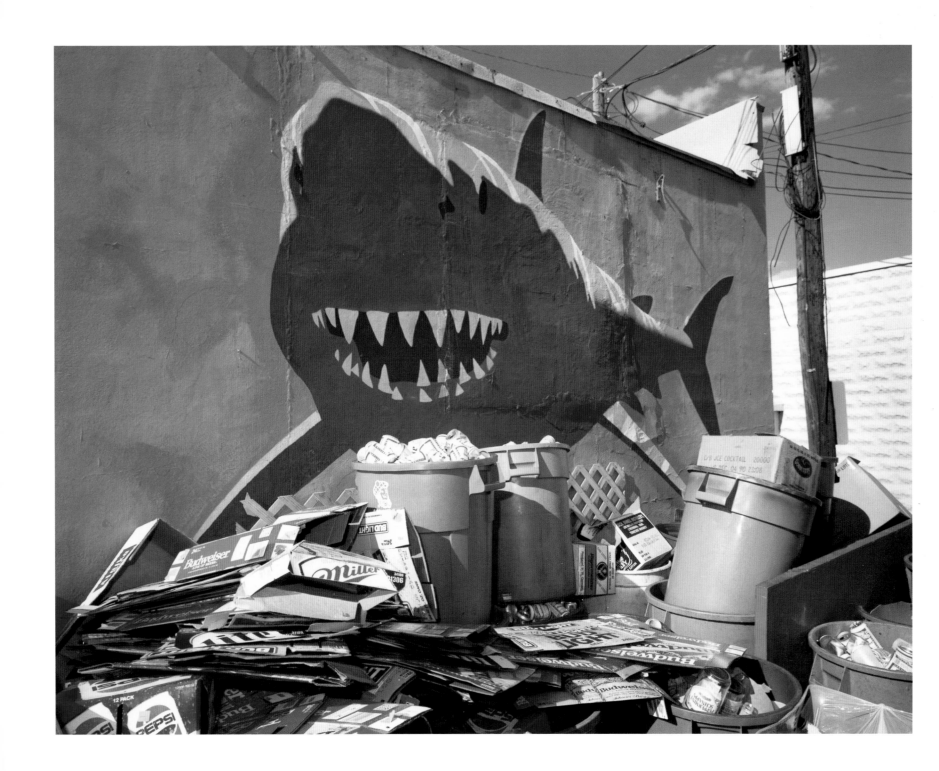

Daytona Beach, Florida 1991

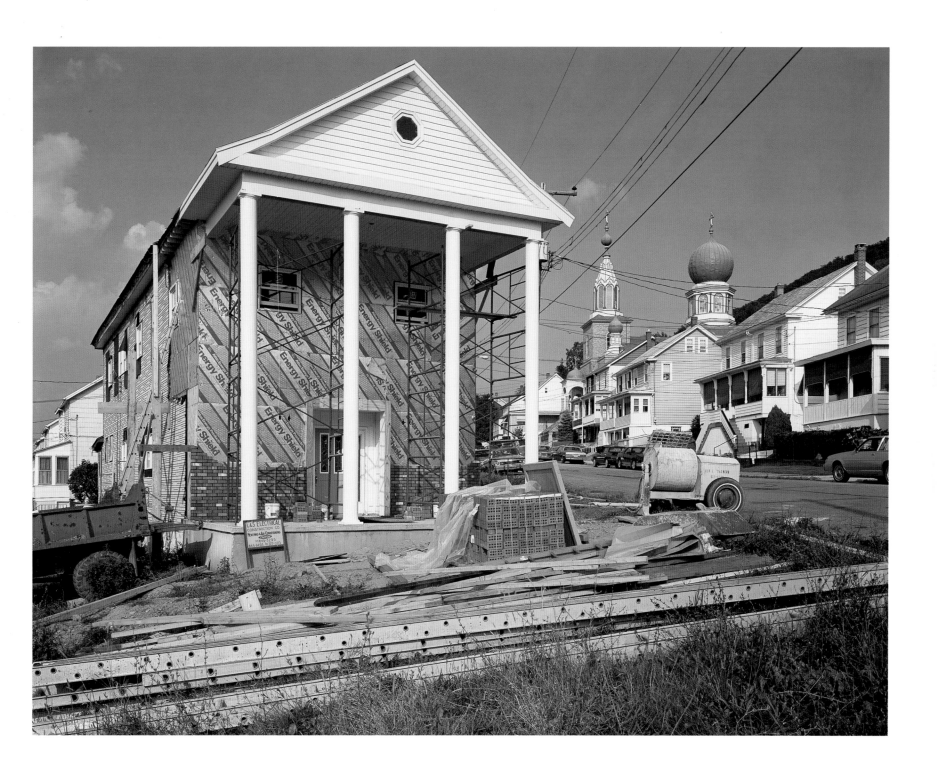

Nesquehoning, Pennsylvania 1989

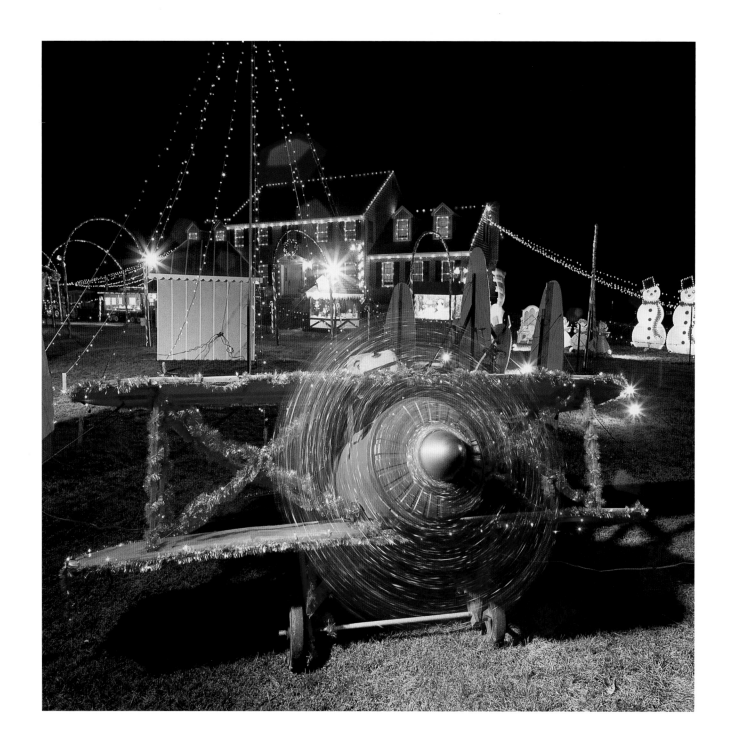

Folly Road, Warminster, Pennsylvania 1991

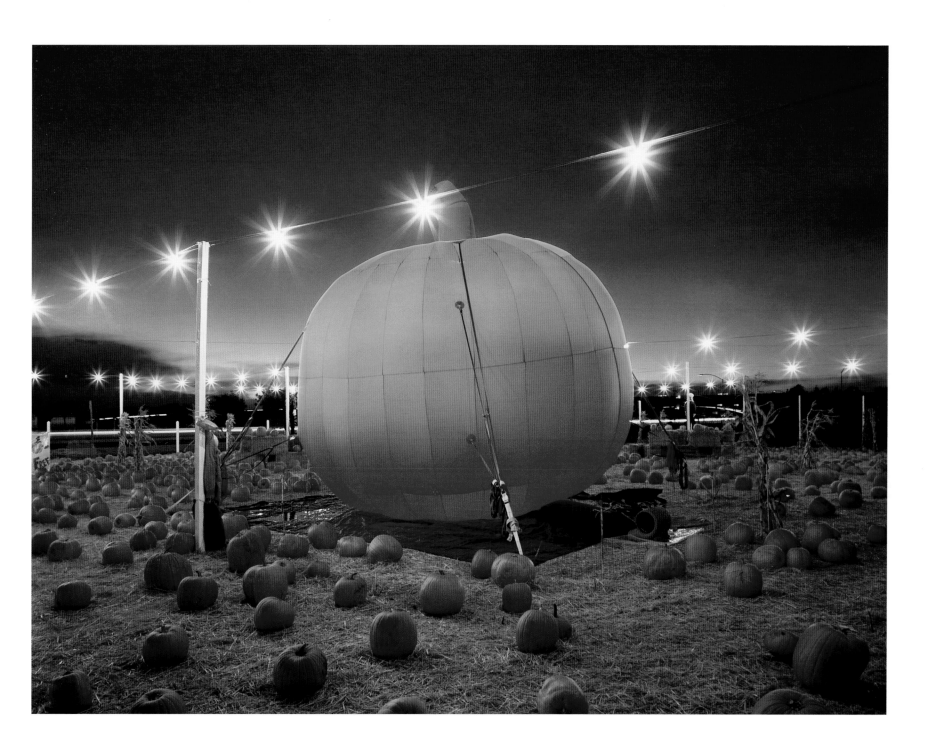

Near Watsonville, California 1989

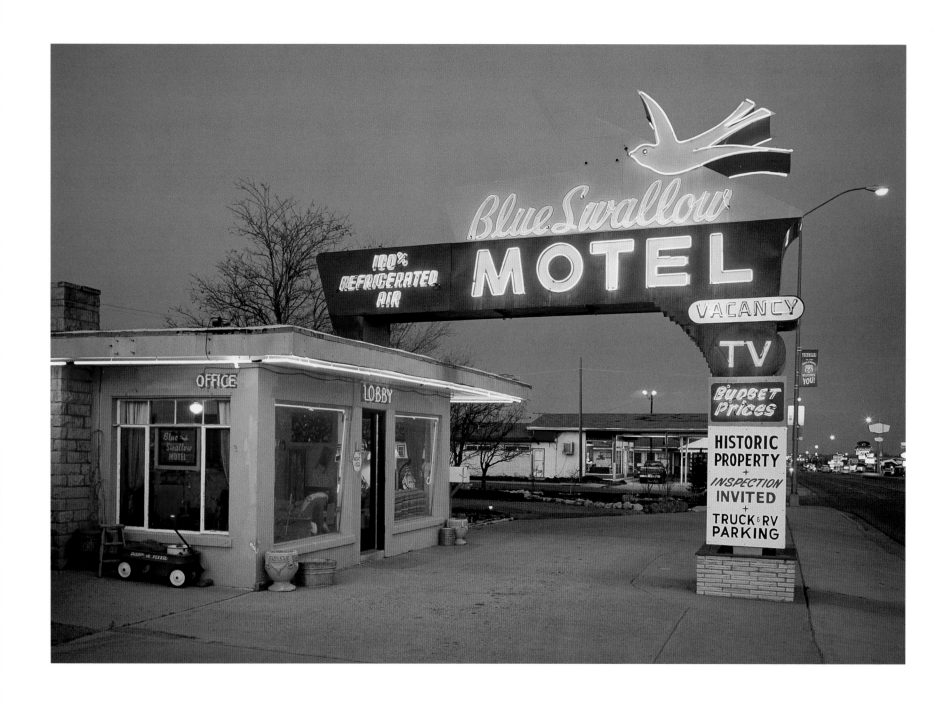

Tucumcari, New Mexico 2001

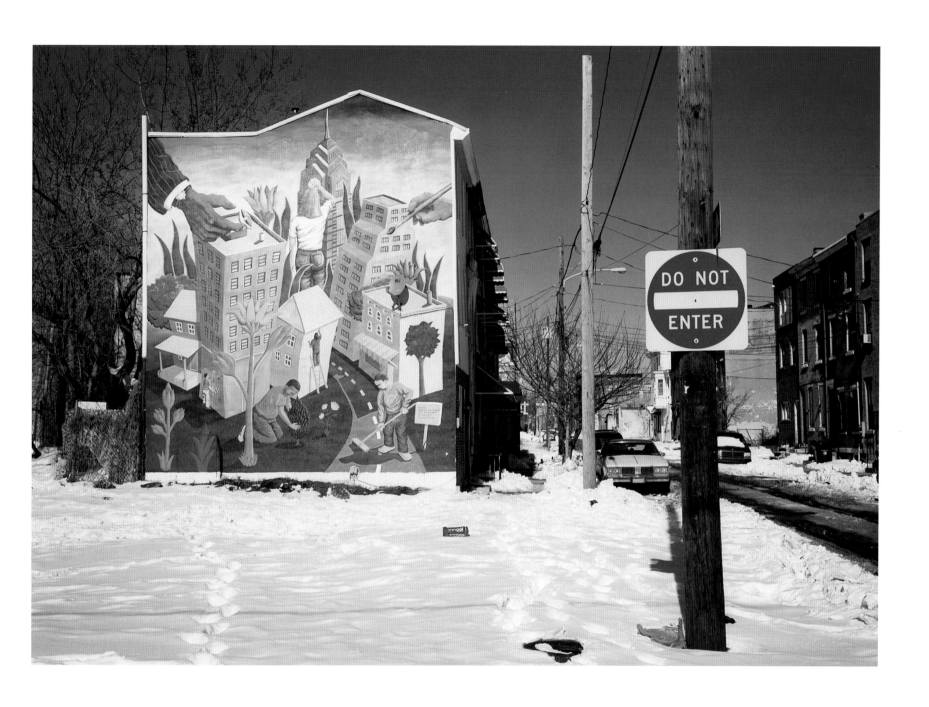

15th & Ridge, Philadelphia, Pennsylvania 2000

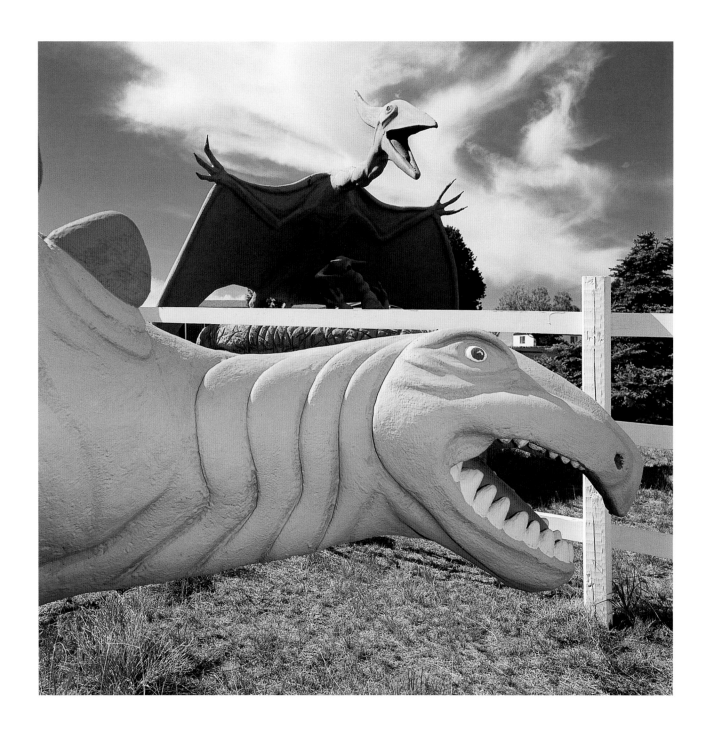

Santa Fe, New Mexico 1995

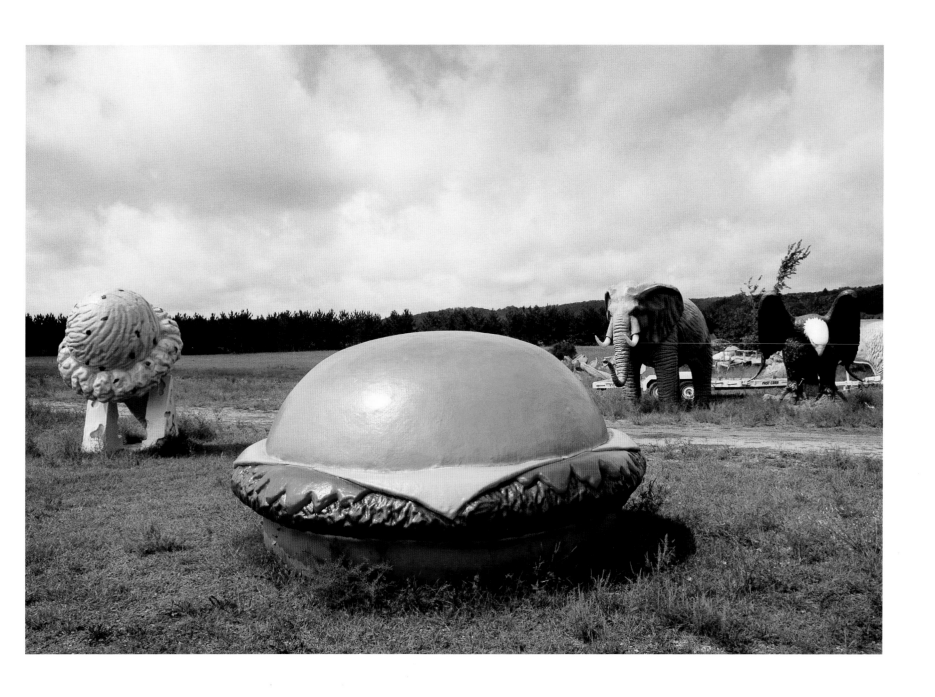

FAST Corp., Sparta, Wisconsin 1988

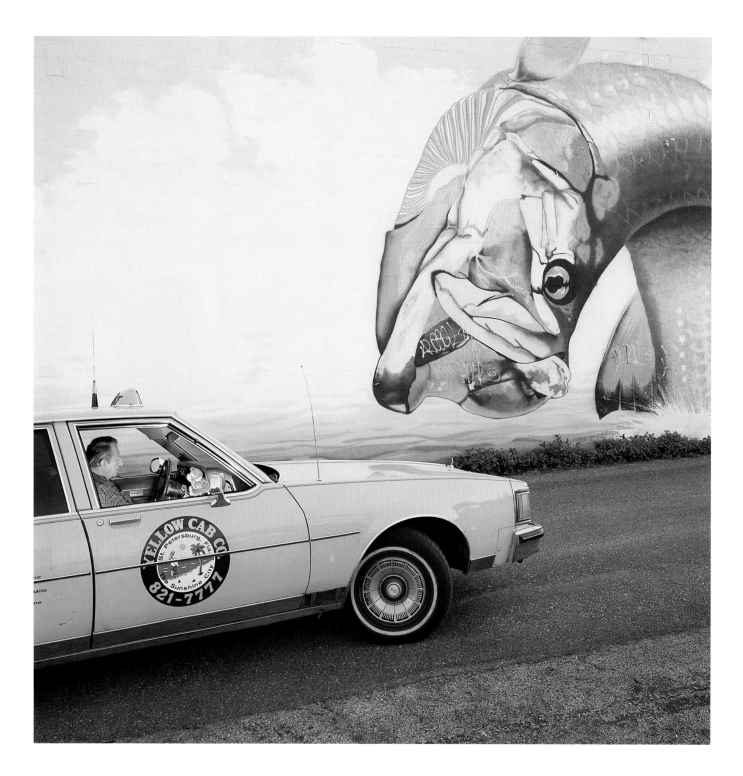

John Mc Elwee, St. Petersburg, Florida 1994

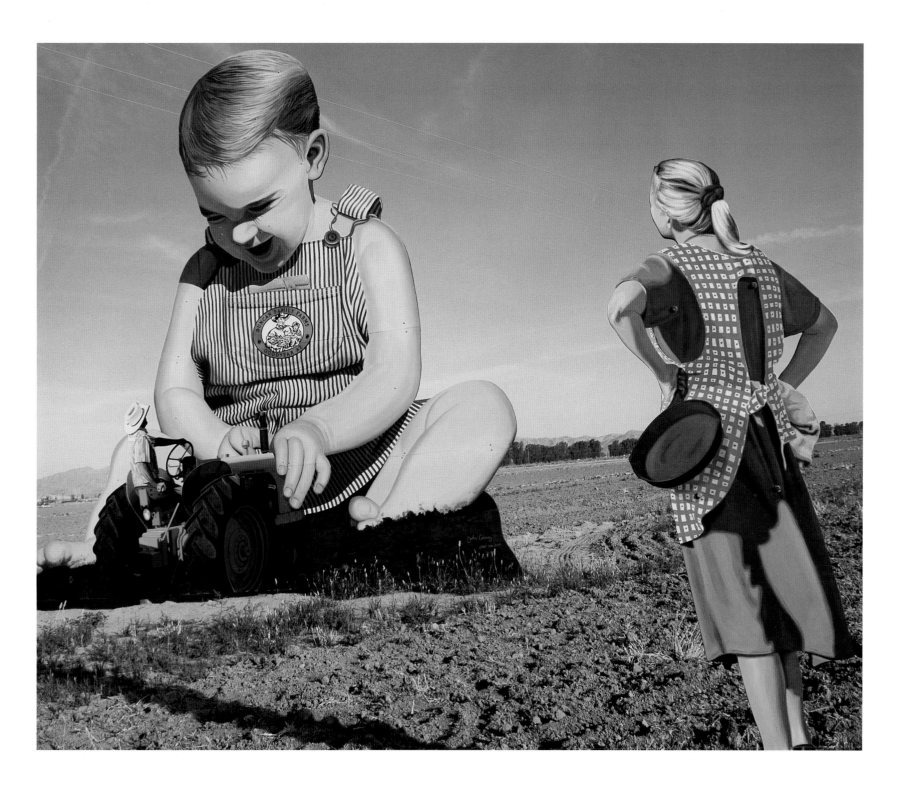

John Cerney's "Big Baby" Mural, Duncan Family Farm, Goodyear, Arizona 1999

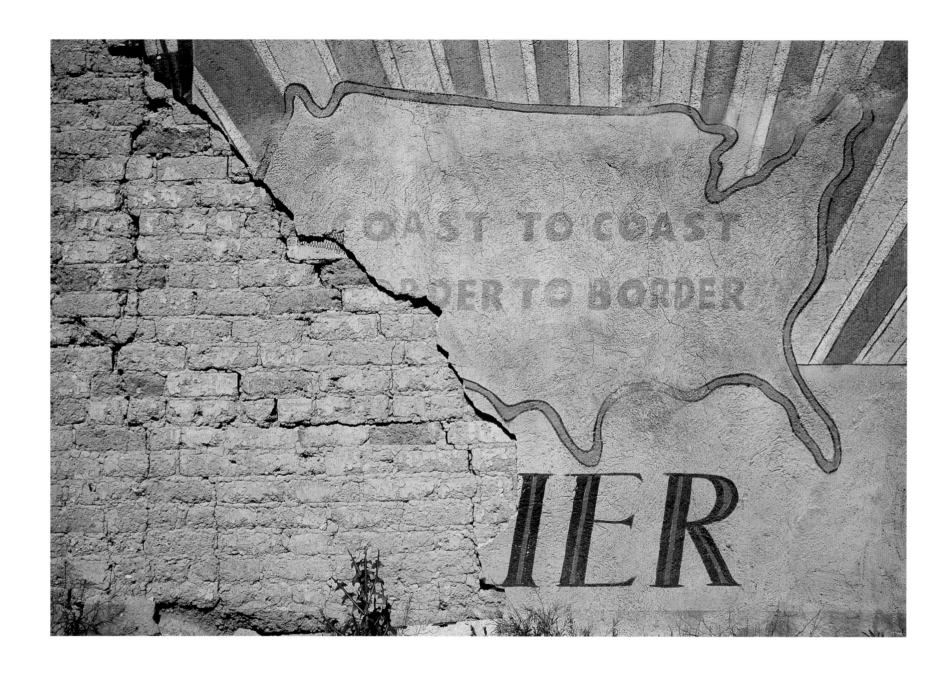

Kingman, Arizona 1995

ABOUT THE TYPE

This book is set in HTF Requiem, a renaissance typeface designed by
Jonathan Hoefler. Requiem is based on a set of engraved capitals
probably cut by Ugo da Carpi, and featured in Ludovico Vicentino degli
Arrighi's 1523 writing manual, *Il Modo de Temperare le Penne*. The roman and
italic lowercase are of original design, quoting freely from the lettering
of Arrighi's contemporaries Giovanni Cresci and Giambattista Palatino.